PORTRAIT OF THE

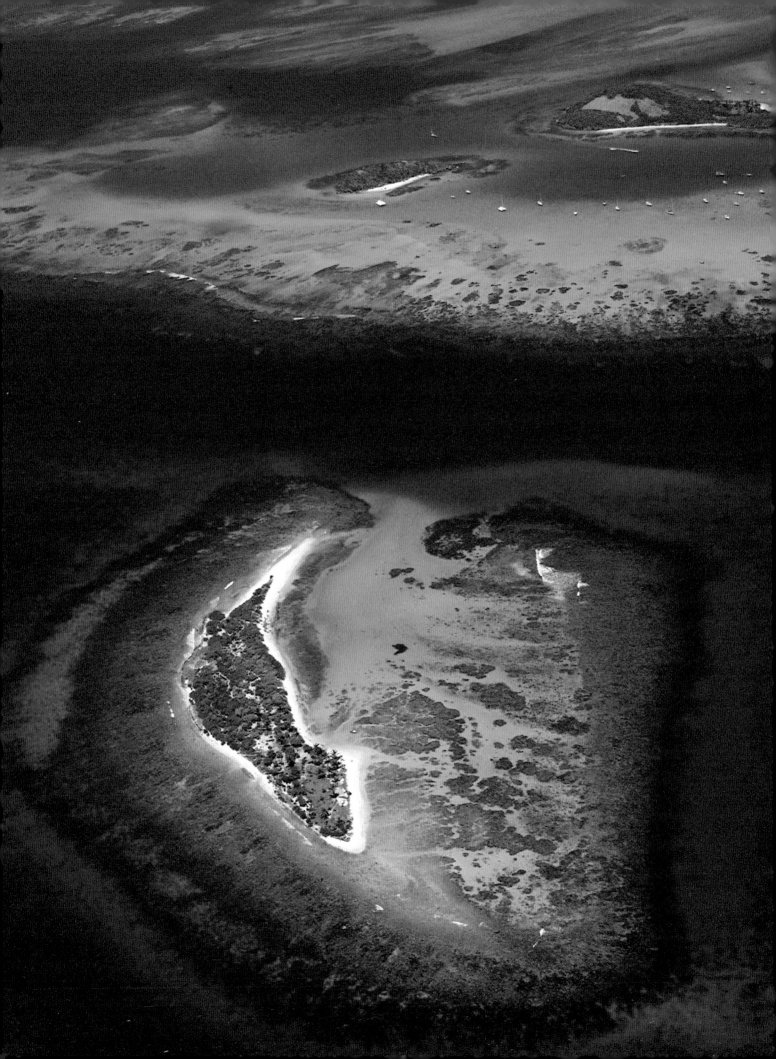

PORTRAIT OF THE

CARIBBEAN

PHOTOGRAPHY BY BOB KRIST • TEXT BY MARGARET ZELLERS

GRAPHIC ARTS CENTER PUBLISHING™

ISBN 1-55868-204-X
Library or Congress Number 94-79353
Text © MCMXCV by Margaret Zellers
Photographs © MCMXCV by Bob Krist
Published by Graphic Arts Center
Publishing Company
P.O. Box 10306 • Portland, OR 97210
President • Charles M. Hopkins
Editor-in-Chief • Douglas A. Pfeiffer
Managing Editor • Jean Andrews
Production Manager • Richard L. Owsiany
Cartographer • Manoa Mapworks, Inc.
Typographer • Harrison Typesetting, Inc.
Color Separations • Color Magic, Inc.
Printer • Color Magic, Inc.
Bindery • Lincoln & Allen
Printed and bound in the USA

Front Cover Photograph: The Baths, in the British Virgin Islands' Virgin Gorda, is a popular anchorage. Snorkelers explore caves that have formed among the rocks. *Back Cover Photograph:* St. Lucia's Pitons are impressive landmarks, made even more dramatic with a rainbow garland and flowering trees. *Frontispiece:* The Caribbean islands are legendary, whether the top of a mountain range that pierces the sea or a living coral community whose earliest organisms provide the anchor for those now being formed. The people and the places live—not only unto themselves but also in our memories.

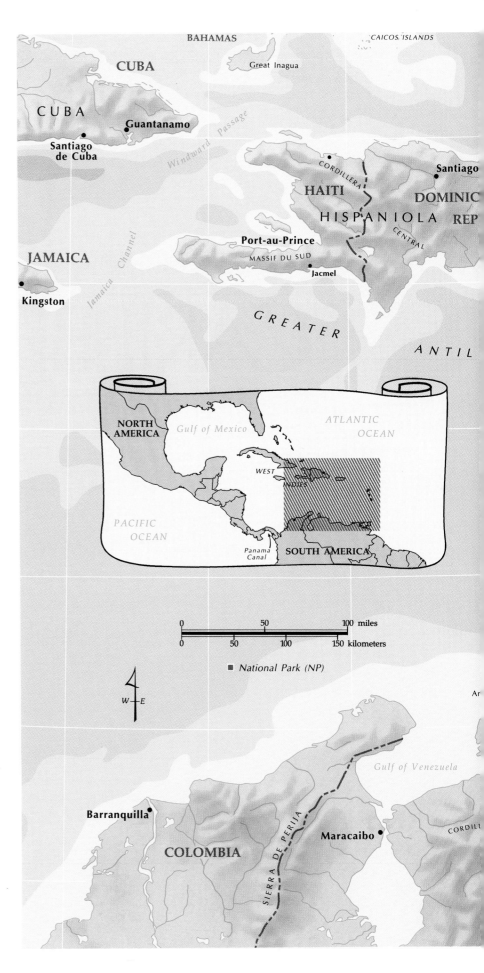

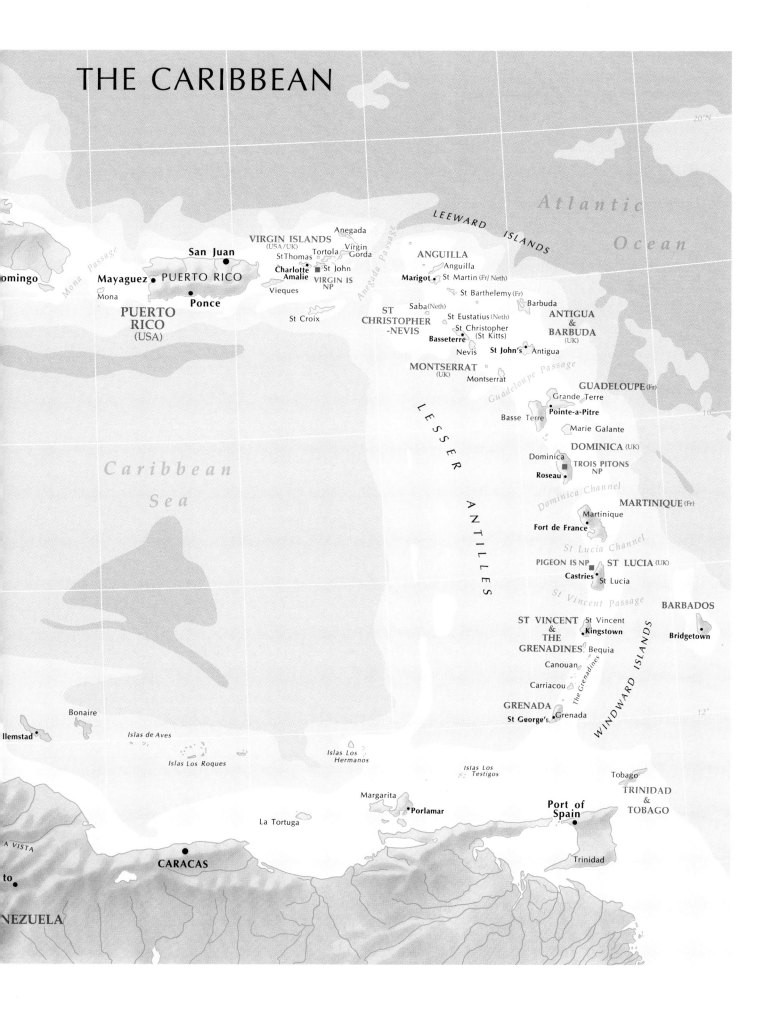

THE CARIBBEAN

Atlantic

Ocean

20°N

LEEWARD ISLANDS

Anegada

VIRGIN ISLANDS
(USA/UK)

ANGUILLA
Anguilla

San Juan

StThomas
Tortola
Virgin
Gorda

Mona
Passage

Charlotte
Amalie
St John

Marigot
St Martin (Fr/ Neth)

Mayaguez
PUERTO RICO

VIRGIN IS
NP

St Barthelemy (Fr)

omingo

Vieques

Saba(Neth)
Barbuda

Ponce

Anegada Passage

St Eustatius (Neth)

ANTIGUA
&
BARBUDA
(UK)

PUERTO
RICO
(USA)

Mona

St Croix

ST
CHRISTOPHER
-NEVIS

St Christopher
(St Kitts)

Basseterre

Nevis
St John's
Antigua

MONTSERRAT
(UK)
Montserrat

GUADELOUPE (Fr)
Grande Terre
Pointe-a-Pitre

Guadeloupe Passage

Basse Terre
Marie Galante

Caribbean

Sea

LESSER

DOMINICA (UK)
Dominica
TROIS PITONS
NP
Roseau

Dominica Channel

ANTILLES

MARTINIQUE (Fr)
Martinique
Fort de France

St Lucia Channel

PIGEON IS NP
ST LUCIA (UK)
Castries
St Lucia

St Vincent Passage

BARBADOS

ST VINCENT
&
THE
GRENADINES
St Vincent
Kingstown
Bequia

Bridgetown

Canouan

The Grenadines

WINDWARD ISLANDS

Bonaire

Carriacou

llemstad

Islas de Aves

GRENADA
St George's
Grenada

12°

Islas Los Roques

Islas Los
Hermanos

Islas Los
Testigos

Tobago

Margarita

TRINIDAD
&
TOBAGO

La Tortuga

Porlamar

Port of
Spain

A VISTA

CARACAS

to

Trinidad

NEZUELA

16°

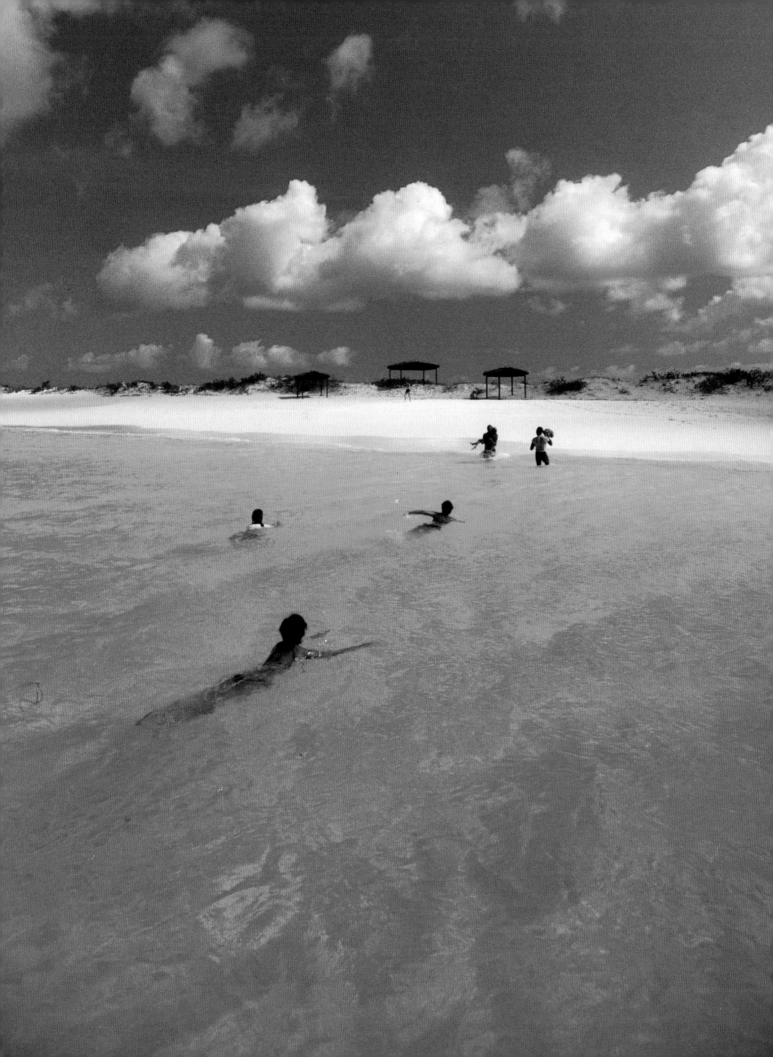

White sand, as soft as talcum powder, stretches as far as the eye can see. The only footprints along the beach are mine, on this first walk of the morning, and the only other marks on my path are from sea creatures that felt secure enough to forage in the pre-dawn stillness—or were tossed there by a roiling wave.

The sea that laps the shoreline, and sometimes my toes, is just about body temperature—slightly above or slightly below, depending on when and where I happen to swim, how deep I dive, how long it has been toasted by the Caribbean sunshine, and the time of the year. (The sea temperature varies about ten degrees from summer to winter.)

Life in the Caribbean seems serene. Perhaps that is its charm. Certainly that is part of it. But the region is curious with its contrasts. We dream of a place that is carefree, bathed in constant sunshine (except when it is blanketed by starlit nights), cooled by ever-present breezes, and decorated with sensational flowers set against verdant foliage. We see smiling people waiting to welcome us. We anticipate comfort and coddling.

But the Caribbean is also a region of violence, as the Arawaks discovered when they were invaded by the Caribs, and both the Arawaks and the Caribs found when they were set upon by the Spaniards, and the Spaniards learned from the British or the French (and vice versa), and so on through the islands' history. It is even true these days, although invasions are usually limited to tourists.

The Caribbean is a region where hurricanes have splintered buildings, broken trees like matchsticks, and given once-lush islands a brutal crew cut in a few hours; where earthquakes have dumped thriving communities into the sea, such as happened at Jamaica's Port Royal in 1692; and where volcanoes have erupted, burying an entire town, as happened in Martinique in 1902.

Perhaps it is the contrasts that have given the islands their magic—the perfection of nature and the not-so-perfect lines of modern construction; the semblance of luxury and the West Indians' resentment of servitude; the complexions of people, from darkest ebony to sun-pinked white.

"Islomanes" is what Lawrence Durrell has called those of us addicted to islands, but no one has clearly defined the island appeal. What draws us to these specks in the sea? Is it the search for "paradise"? The lure of adventure? The temptation of new horizons? Is it the pursuit of a dream? Do we hope for a "perfect" place with a simpler, saner life? Were we all enchanted as children by Robinson Crusoe? Did we perceive Swiss Family Robinson to have the ideal lifestyle?

We search, like Diogenes looking for an honest man, for paradise; many ignore problems to find it in the Caribbean.

The finite boundaries of islands fool us into believing that islands are easy to understand. They are not. Especially in the Caribbean. The only certainty is that no two islands are exactly alike, even when they share a common government. History and natural attributes conspire to make each one different.

Just like people, each island has its own personality. Thus, once-British Jamaica is not like Puerto Rico with its Spanish heritage, even though nature has endowed them with similar characteristics and they are almost the same size.

And the Latino Dominican Republic is very different from the French-affected Haiti, although both share the island of Hispaniola. Dutch Sint Maarten is also different from French St. Martin, in spite of the fact that tourism has stomped with a heavy foot on the small island they share. And Nevis is different from St. Kitts, although the two islands are a single independent Caribbean country with a British heritage.

The Caribbean sea, an oval area about sixteen hundred miles east to west and seven hundred miles north to south, serves as a buffer between the south coast of the United States and the north coast of South America. Most of the islands are like pickets of a curving fence, separating the Atlantic Ocean from a sea cupped by the east coast of Central America.

Though there are hundreds of islands, only a few—Jamaica, the Cayman Islands, Mexico's Cozumel and Isla Mujeres, Colombia's San Andres, Venezuela's Margarita, and the Dutch-affiliated Aruba, Bonaire, and Curaçao among them—are entirely surrounded by the Caribbean Sea.

Most have either southern or western shores (sometimes both) washed by the Caribbean, and some—the islands of the Bahamas, Turks and Caicos, and Barbados—are surrounded by the Atlantic Ocean, although they share the history and the sun-struck lifestyle of their neighbors.

Some of the islands are independent countries. Haiti was the first. It became independent in 1804, followed by the Dominican Republic in 1844, and Cuba in 1898. These days, most of the islands are independent, having become so since 1962. A few islands are still dependent territories, albeit in a modern way that yanks them from the former "colony" status and gives each a strong measure of self-government.

Thus, Anguilla, the British Virgin Islands, the Cayman Islands, Montserrat, and Turks and Caicos islands are British affiliated; the United States watches over the Commonwealth of Puerto Rico and the multi-island territory of the U.S. Virgin Islands (St. Croix, St. John, and St. Thomas); and the Netherlands government has a symbiotic relationship with Sint Maarten, Saba, Sint Eustatius, Aruba, Bonaire, and Curaçao.

Geologists suspect that a few of the northern islands—notably Cuba and Hispaniola—may have been part of the landmass of eastern Mexico; and a few southern islands—Trinidad, for sure—broke from the coast of South America. But these mountainous islands are only part of the picture.

The "seven hundred islands" of the Bahamas, east and south of the tip of Florida, are basically flat with an occasional hill, and

◄ *Finding a beach where your footprints can be the first may seem difficult, but it is not impossible in the Caribbean.*

groves of feathery island pines in the few places where tourism, lumbering, and development have not mowed them away. The Turks and Caicos islands, separated from each other by the twenty-two-mile-wide Columbus Passage, which plunges to a depth of seven thousand feet and was known as the Turks Islands Passage until recent renaming, are flat and sand-fringed, with dramatic scenery under the sea where it is enjoyed by divers.

Cuba, less than ninety miles south of Florida's tip and stretching toward Mexico's Yucatan Peninsula, is the largest of the Caribbean islands. And Cuba plus Jamaica, Hispaniola, and Puerto Rico make up the Greater Antilles, a traditional term for the large islands that define, east to west, the northern rim of the Caribbean Sea. Each has a mountainous spine, where verdant forests hide waterfalls, lakes, and endemic birds, and much of the interior's tropical growth is seldom, if ever, explored. The beaches that fringe some of the shoreline come in shades from butterscotch-brown to cornstarch-white. And hotels and resorts mark some, but by no means all, of the strands.

Puerto Rico's varied landscape, with foliage-covered mountains that drop to southern plains, is reflected, in smaller, less dramatic versions, on its satellite islands of Vieques and Culebra, and even the U.S. Virgin Islands (St. Croix, St. John, and St. Thomas). All lie farther east as the start of the Lesser Antilles, a catch-all name for the rest of the Caribbean islands.

A cluster of islands—including the British and U.S. Virgins—are separated by the lively seas of Anegada Passage from the flat-and-sandy Anguilla and the resort-studded Sint Maarten/St. Martin, to the east, before the island chain begins its long reach south.

Saba and Sint Eustatius, Dutch-affiliated southern neighbors of Sint Maarten, are mostly cones of dormant volcanoes with verdant flanks that invite exploring. Although scuba divers are lured by shipwrecks and the sea life offshore, the beaches are not the best. (In the case of Saba, there are none worth the name.)

Beaches are better on Antigua, which is vaguely mountainous and rimmed with soft, white sand at almost every cove, and on Barbuda, its flat-as-a-pancake sister island that lies several miles northeast. There are also lovely beaches along the south coast of St. Kitts, where a recently opened, U.S.-financed scenic road carves the first paved land route down the length of the mountainous peninsula that points toward Nevis.

The northern sector of St. Kitts, as well as its sister island of Nevis, is marked by volcanic peaks, where slopes have nurtured once-British plantations that have become charming inns. Nearby British Montserrat is also a volcanic island, where soft, grey-to-black sand fringes a few of the most accessible shores, but beige sand borders a boat-reached cove.

The French department of Guadeloupe lies within view to the southeast. The "island" is actually two islands linked by a bridge, with the mountainous terrain of a lush volcanic island on western Basse-Terre and the flatter, sand-fringed landscape expected at beach resorts on eastern Grande-Terre. Its satellite of St. Barthélémy is far to the north, closer to Sint Maarten than to Guadeloupe. The eight tiny islands of the Iles des Saintes are off Guadeloupe's south coast; Marie-Galante lies east of Basse-Terre and south of Grande-Terre; and Le Desirade is slightly east of the northern part of Grande-Terre.

Dramatically different Dominica is the nearest neighbor heading south. Home to the purest surviving Carib community (there is another group on St. Vincent, and others live on Belize and Honduras), Dominica also has more breathtaking scenery and more endemic parrots (two species) than any other island. Dominicans (pronounced *Dough-min-EE-cans,* not to be confused with the like-spelled, Spanish-speaking *Do-MIN-nee-cans* from the Dominican Republic) share a créole language and commerce with their French neighbors, although the independent country follows a British style of government adapted from its former colonial power.

Mountainous Martinique, which shares créole customs and the colorful Madras traditional dress with its French relative, Guadeloupe, claims a news-making volcano, Mont Pelée. Its eruption destroyed the town of St. Pierre and sent shock waves through the rest of the region. Its southern beaches and active marinas belie the terror of that time.

St. Lucia, whose dramatic twin peaks—the Pitons—are in sight off the south coast of Martinique, is next in the island chain. While its mountainous spine is wilderness and a few of its west coast beaches are flecked with resort hotels, St. Lucia's east coast and its lifestyle remain uniquely its own. French neighbors and a seesawing French and British colonial rule have knit the fabric of daily life.

Similar in terrain but with a volcanic peak in its northern sector, St. Vincent continues to move outside the tourism mainstream, developing the better beaches and surrounding seas of its Grenadine islands to the south for sailors, scuba divers, and other adventurers.

Grenada, at the end of the string of tiny Grenadine islands and claiming two (Carriacou and Petit Martinique) as its own, is also volcanic. Its mid-island crater lake is a nature preserve, and its northern sector is virtually untouched. Tourism claims the south coast, where white-sand beaches slope gently into the sea.

Barbados, in the southeast, is the first and only scout to face the Atlantic seas on their unchecked advance from African shores. Tourism has been a long-standing fact of life, not only for eighteenth-century British, eager to visit when the winter winds whipped the British Isles, but also for George Washington, who visited his brother, Lawrence, here. Cane fields cover most of this coral island, but resorts are etched onto the west and south coasts, leaving the rugged, wind-buffeted east coast and mid-island sugar plantations as relief from rampant development.

Trinidad and Tobago, one country with two islands that have distinct personalities, is a microcosm of Caribbean landscapes.

"Jacquot" is what St. Lucians call their endemic parrot, now protected through Forestry Department efforts. ▶

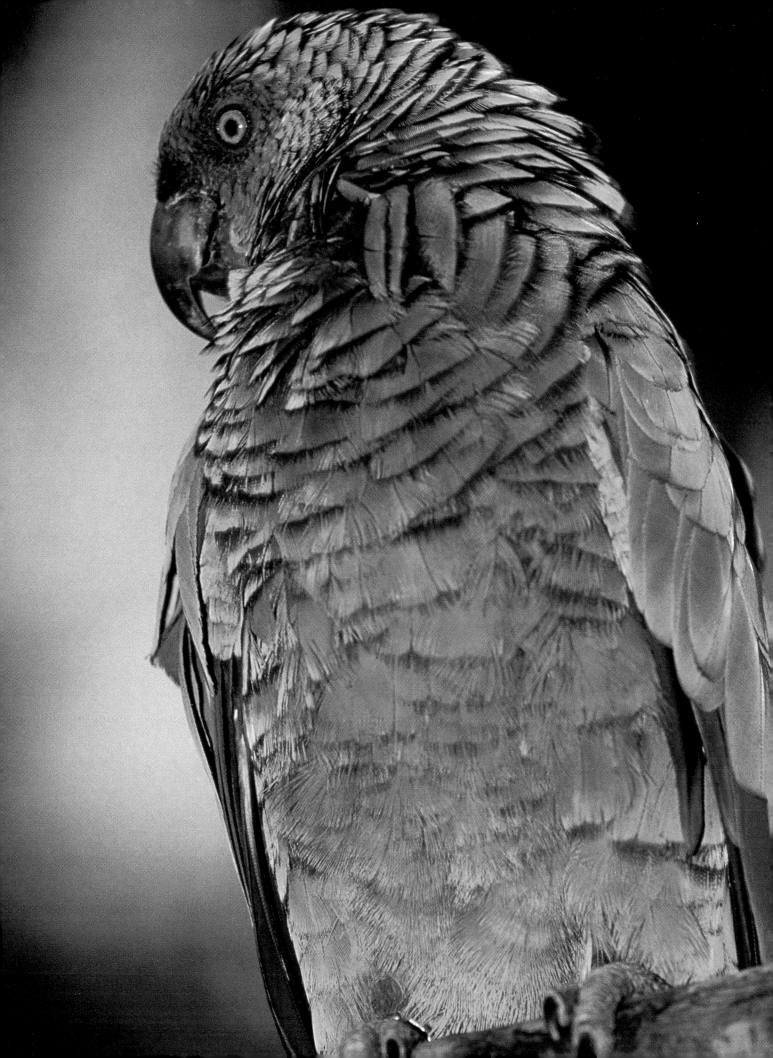

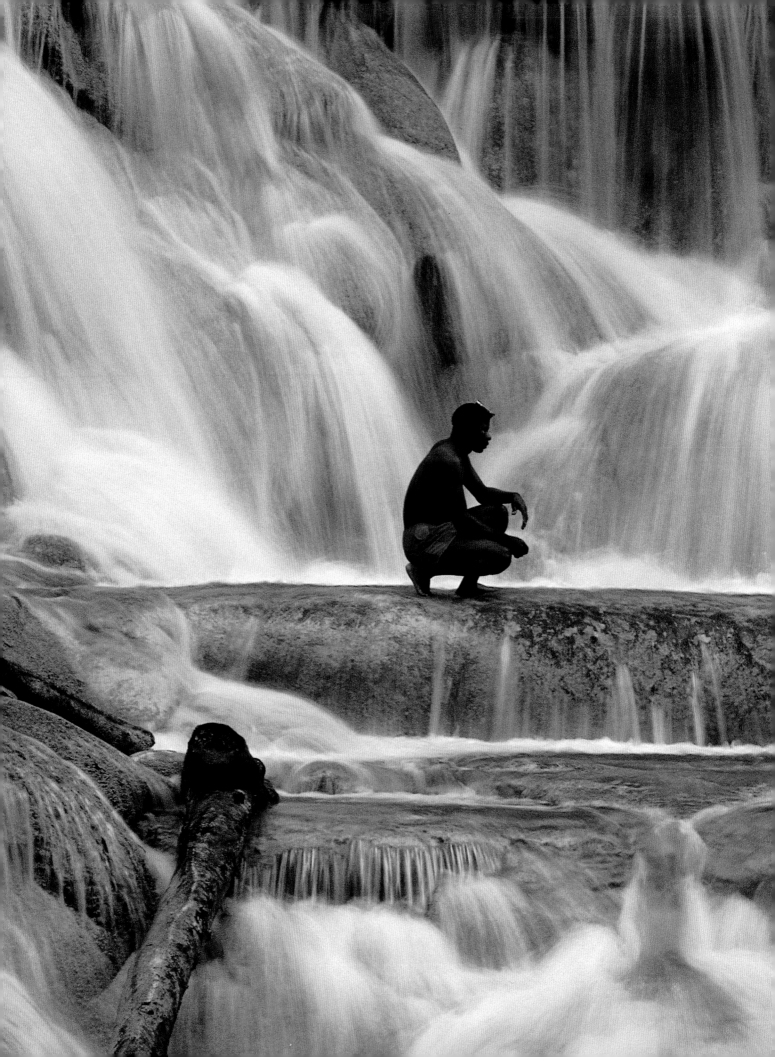

While Trinidad's cosmopolitan capital of Port of Spain is home for a multi-racial population, most of the rest of the island is little known to outsiders. A nature center hides in the northern mountain range, flocks of scarlet ibis nest near the capital, and asphalt from mid-island pits was used to caulk the ships of Sir Francis Drake and pave the streets of towns in the United States.

Tobago, meanwhile, maintains a more traditional island style, with beige beaches, resort hotels, and a hinterland best known to birds and other natural residents. Its offshore reefs lure adventuresome divers.

A trio of Dutch-linked islands (Aruba, Bonaire, and Curaçao) sits off the Venezuelan coast to the west. Flat coral outcroppings with desertlike terrain, these islands are marked by unusual hills, caves known to the earliest settlers, and—in the case of Bonaire—a resident crop of flamingos that make the island their winter home.

And so it goes, from north to south, through the litany of the best-known vacation islands. But there are more. Margarita, to the north of mother-country Venezuela, is tied to a South American lifestyle, as are sleepy San Andres and its sister, Providencia (confused by some with Providenciales, far north in the Turks and Caicos islands). San Andres and Providencia are both Colombian.

Off the coast of Honduras, the Islas de la Bahia are known to sailors and scuba divers, most of whom focus on Roatan for expected comforts. The independent country of British-affiliated Belize is now being rediscovered by intrepid scuba divers and environmentalists. Its history, however, is firmly forged to the eastern islands.

Though all have been found—and named—many islands sleep under the Caribbean sun, far from familiar tourist routes. Modern comforts may not be in place, but nature's attributes are refreshingly secure. The magic of untrammeled islands can still be enjoyed. The days for rediscoveries are dawning.

For me, it is the people that make the place. Even though I often return to the islands, it is the people who introduced me to these places that I remember when I am there—and that bring joy to my memories when I am away. Several years ago, in a closet-sized atelier in the slightly scruffy warren of shops that grew on eighteenth-century pirate warehouse walls in downtown St. Thomas, there was an elderly man who nurtured metal into fine jewelry.

By the time I met him, he was nearly blind, but Mr. Callwood appeared in his shop most mornings, to create fine jewelry in the warm sun splashing through his open window. For years, I have worn the gold bracelet he made in his version of the ancient slave bracelets; and for years I have remembered his tales of childhood life on that now-frantic U.S. Virgin Island, where shoppers surge most days, unchecked except by the size of their bank account, in search of treasures.

The islands were still Danish when Mr. Callwood was a boy. They became American in 1917, when the U.S. government bought them for $25 million, as a buffer in time of war. Coming to town was a big occasion for people who lived on the far side of the island, less than three miles away. It meant walking or riding a donkey for most people, following a serpentine, unpaved route up and over the mountain spine. Cars were scarce; commerce, negligible. It would be several years before cruise ships and tourism would become a daily fact of life.

Even by the late 1950s, there were none of the traffic jams that now clog the waterfront road—and few of the hotels that now embroider most sandy coves. People made time for polite conversation, whch always began with proper greetings: a long and thoughtful "Good morning," "Good afternoon," or "Good evening," depending on the time of day. And the greeting always earned a considered and pleasant response, most often accompanied by a smile.

That is still the case on some islands, where commerce has not yet caught the plague of more cosmopolitan centers. On Dominica, for example, I recently spent the better part of a day with Henry, who returned last year from London, where he had been studying law. He chose to come home with his family, to make his living on Dominica. He has also chosen to follow Rastafarian beliefs, giving his two young sons African names and wrapping his long-and-gnarled dreadlocks in a gauzelike turban that suggests Sikh Indian style. He continues to pursue his study of law, intending to draft environmental legislation—before the Caribbean landscape is irrevocably changed. In tandem, he shares with visitors knowledge of his country's rich heritage— and contributes to the family coffers. His wife works in her parents' business, which includes tourism ventures as well as the construction business that had been her father's original trade.

Other days on other islands, I pick up school children in my rental car, to learn from them as I drive them to or from school. Always they are tidy in their uniforms, dictated by traditional British custom, though adapted to the vagaries of Caribbean life. Sometimes blue and yellow, other times beige and brown or another combination, the uniforms come in all sizes and shapes. In at least one case, the girls' red skirts and boys' red trousers, topped with white shirts, were chosen for the colors of the Canadian flag, in gratitude because Canada had financed their school, just north of Castries, St. Lucia's capital.

As recently as 1977, the St. Lucian Parrot flirted with extinction. Once common, the parrot population was down to about a hundred. The birds' natural forest habitat had been gradually destroyed, cleared for fields of sugar cane and other crops, for living areas for an expanding population, as well as to use for fuel and lumber. By 1987, after a decade of intense conservation efforts by the St. Lucian Forestry Department, the parrot population had increased to almost two hundred fifty birds. Since that time, the parrot population continues to increase.

◀ *While some Jamaicans work as guides for the climb up the falls, others use the rocks and pools as their path to work in Ocho Rios.*

Another benefit has been local awareness about how fragile island landscapes can be preserved and enhanced.

Endangered species and protection of the environment are the focus for many residents and concerned visitors. Noting that rare bird species and the island's ecosystem are threatened by population growth, farming, tourism, lumbering, and other factors, islanders have been encouraged to protect the Montserrat oriole *(Icterus oberi)* and parrots such as the *Amazona guildingii* of St. Vincent; the *Amazona imperialis* and *Amazona aurasoaca* of Dominica; and the Cayman Islands parrot and the Bahamas parrot, both subspecies of the *Amazona leucocephala,* popularly known as the Cuban Parrot.

Monique came directly from Bahamas Community College to her conservation work with Bahamas Forestry Department. When she visits the schools and other congregating centers, she will be guided by a program that includes puppet shows, songs, games, and other activities to make the parrot and his peril meaningful to the daily life of the islands. For the Bahamas, the bird has special importance: it was noted by Columbus when he arrived on San Salvador, claimed by most as the European traveler's first Caribbean landfall in 1492.

But the Bahamas are nesting grounds for many birds. In early morning on Crooked Island, if you look south toward Long Cay, you may see *Phoenicopterus ruber,* West Indian pink flamingos, as they fly from their marshland feeding areas to the sand banks. They are also common around Inagua Island.

The saline waters where flamingos find the algae food that keeps them pink are the same waters ideal for the salt industry that gave many islands their early prosperity. But, since flocks of wild flamingos linger only where people are not, the arrival of Morton Salt Company on Inagua in 1954, when they purchased a family business, was greeted with apprehension.

Local folks feared the worst, even though they were pleased that the revitalized salt harvesting had caught the eye of international entrepreneurs. Morton Salt proved to be a good neighbor, however, both in deed and in fact. They have maintained some of the salt marshes favored by the birds and have donated significant sums to the Bahamas National Trust for the National Park that is a habitat for many water birds.

Likewise on Bonaire, commercial ventures have proved compatible with wildlife preserves. On the island's southern tip, the Antilles International Salt Company has set aside a flamingo sanctuary, though some birds seem to prefer the company's well-tended salt pans as their restaurant-of-choice.

On other islands, there are other birds—and other environmental concerns. Trinidad has its flocks of scarlet ibis that nest at the Caroni Bird Sanctuary, not far from the country's capital of Port of Spain. And toucans, squirrel cuckoos, and other birds make their home in its Asa Wright Nature Centre, at Spring Hill Estate. Located in the northern mountain range, it is an area that continues to thrive away from the mainstream of development.

Tobago, marked for expanded tourism development by its government authorities, is home to hundreds of birds in its little-known interior, but the once-thriving bird of paradise, imported to a small island off the southern shore, vanished long ago. Only its name remains, as the tag for an island dot.

Children cluster around the ice-cone cart near the gates of Jamaica's Hope Botanical Gardens. Adults either yield or lead them away with a promise of "later"—after a stroll through portions of the two-hundred-acre park given to the country by the Hope family, soon after abolition of slavery, in the mid-1800s.

Sunday is the day Kingstonians come to picnic, walk, read, or ride the merry-go-round in the park, but the area is open daily. The Blue Mountains, namesake for the pungent coffee that grows on the upper slopes, rise as an impressive backdrop. They peak at seven thousand feet.

Although Jamaica's capital of Kingston is a busy, sometimes raucous, city and Old Hope Road can be a traffic-clogged artery that makes it easy to miss the garden's gates, an hour's visit is a step into the real life of Jamaica, away from the tourist troughs.

Since the late 1950s, while Caribbean countries have been grappling with the vagaries of independence, botanical gardens and other remnants from colonial life have fallen into disrepair. Only recently have national trust associations, forestry departments, and their ilk had the time (and training) to restore and maintain the legacy.

Although they are assumed to be indigenous, most blossoms that add drama and delight are not. They are merely tourists who took up permanent residence. Some seeds and plants came in the canoes and rafts of the earliest island settlers, from the mainland of North America as well as from South and Central America. But the migration began in earnest when Columbus reached these shores.

In the style of other early explorers, Columbus's ships carried plants for food en route. Later ships would bring the favorite produce from older colonies to the new ones. Thus, ginger made its way from Indonesia; congea, known as "shower of orchids" on some islands, from Burma; bougainvillea, named for French navigator Louis de Bougainville, from Brazil; and the bright red poinsettia that blooms profusely at the Christmas season, from Mexico. The dramatic bird of paradise, with its orange cockscomb and brilliant "beak," is native to South Africa. Heliconia, with its claw-like brackets, was brought from South America and now grows wild on Trinidad, Tobago, and many other islands.

The African tulip tree that Palisot Beauvois noted on the Gold Coast of Africa in 1787 is known by several names throughout the islands. Many believe it has supernatural powers—as well it might—with its towering height, brilliant red blossom clusters, and boat-shaped seed pods. The cottonwood tree also plays a role in island lore as a home for *jumbies,* those spirits that hide in its tangled growth and cavort under its shelter when it rains.

Costumes and carnival capers are an integral part of Caribbean life, whether on Trinidad or another island. ▶

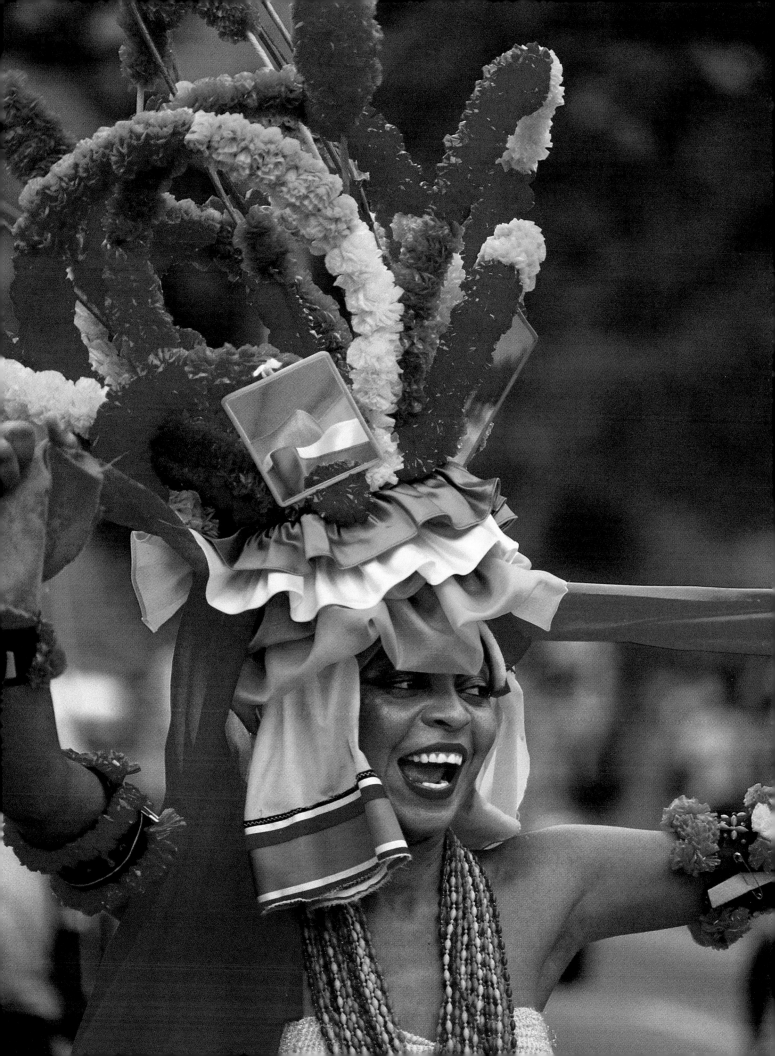

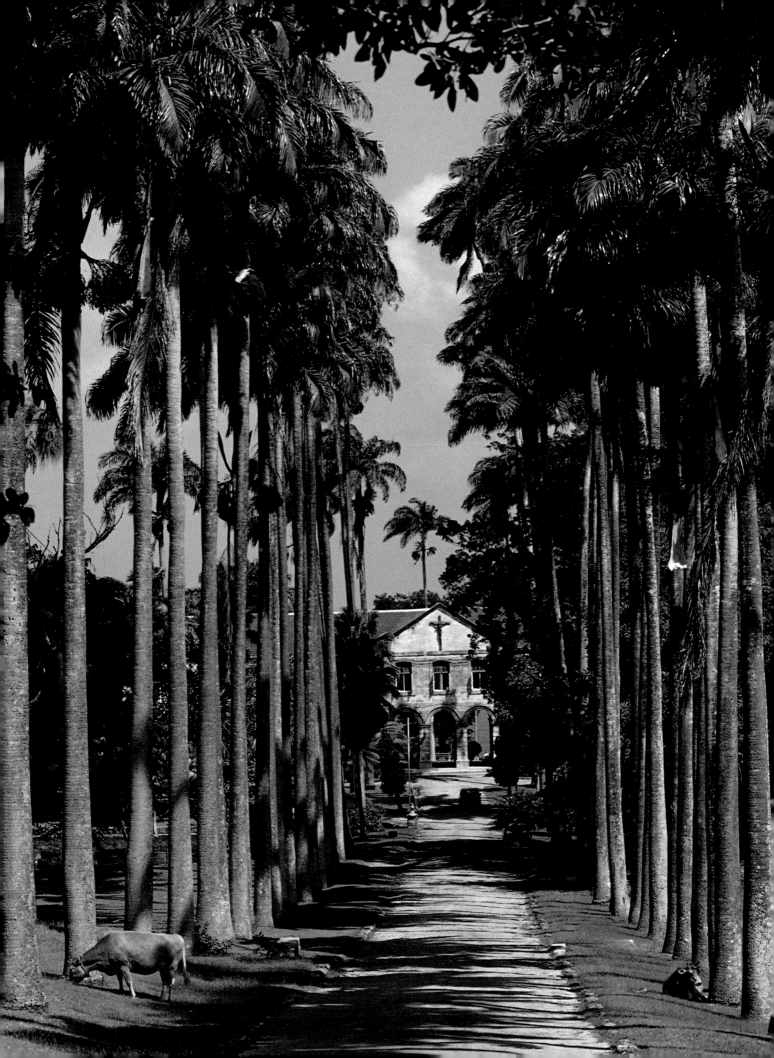

Of all island trees, the dark green, waxy-leaved breadfruit, with its fruit of bowling-ball size, leads with legends. Captain Bligh of Bounty fame brought the seeds to the Caribbean. Whether or not he planted the tree that still stands in the Botanic Garden in Kingstown, St. Vincent, is a matter of speculation, but that he brought the fruit from Africa is documented fact. Breadfruit is still a staple of West Indian diets.

Just as their colonizing was widespread throughout the Caribbean, where most islands and some countries along the Caribbean coast of Central America claim British heritage, so the British also brought their love of botany. They established most of the botanical gardens on Jamaica and on Trinidad, Barbados, St. Vincent, St. Lucia, and Grenada, where they stand today as testimony to British zeal. St. Vincent's King's Hill Forest Reserve, for example, was defined and chartered in 1791, and Dominica's Botanic Gardens near Roseau were established in 1890, although hurricane damage and other exigencies have modified the importance of both.

The lush rain forests—with their cool, moist climate; their broad-leaved planting in shades of green too numerous to count; and their unique, often endangered, species of birds and other fauna—are the special secret of the Caribbean. While Puerto Rico's El Yunque makes a name for itself as host to the only tropical forest under U.S. Forestry jurisdiction, there are many verdant and little-known mountainous areas on that island.

Dominica's fertile forest, portions of which are habitat for the Imperial Parrot that is its national bird, is the largest and most complex rain forest on the Caribbean islands, but there are also verdant areas on Cuba, the Dominican Republic, Guadeloupe, Martinique, St. Lucia, and St. Vincent. Belize is unique with its seldom-explored hinterland, and even developed St. Croix has a rain forest in a northwestern pocket of land.

But not all the islands are lush and green, with vast, natural tropical forests. St. Croix, with a rain forest in one part, slopes to a dry, desertlike peninsula at its easternmost point. Some islands are arid, such as the Dutch-affiliated ABCs—Aruba, Bonaire, and Curaçao—in the southern Caribbean, where the coral limestone islands appear like splinters off the Venezuelan coast. The Watapana tree, permanently bent at a 45-degree angle by the prevailing winds, is better known on Aruba as the DiviDivi tree, the island's national symbol.

On arid islands—or parched portions of islands with varied landscape—cacti bloom, sometimes in groves as in Curaçao's Cristoffel National Park, and elsewhere in isolation, as on most dry islands where the unusual blossoms look as though they have been stuck onto the cactus by some outside force.

Ilodalik's fingers curled like brackets on the frame of the open car window. Rain coursed over his thatch of shiny black hair, making waterfalls from his nose and eyebrows. His eyes gleamed like orbs of coal; his smile was wide and white-toothed, when my questions (or the way I looked) prompted him to make one. Ilodalik is a Carib. He was seven when I met him. His eyes sparkle, and he loves the rain. I loved the shelter inside the car, and the sound of his voice, when I asked him where he lived ("up the hill"), why he wasn't in school ("don't go"), and where his friends had gone when they scattered as I slowed my car on the rutted road ("to get fish"). Our brief encounter—not more than ten minutes, in the Carib community of Dominica—is one of my favorite memories.

Ilodalik is now a grown man. Life in his community has changed, but not beyond recognition. A few older folks still split and weave narrow bands of Wacine-palmiste and vines into fine, firm baskets and make bird cages from Woseau reed once used for arrow shafts. And the skin of bamboo is still woven into fish pots and landing scoops by some fishermen, although most have turned to plastic line and chicken wire for the tools of their trade.

The Caribs and their customs are very much a part of the domestic island life, and their name lives on in the name of the region, whether you choose to pronounce it *Carib-BE-an* or *Ca-RIB-be-an*. (Both are correct.)

The islands of the West Indies, so named by Christopher Columbus in his search for the *East* Indies, were an earlier landfall for Arawaks, Tainos, Ciboneys, and other tribes. Their settlements in the Bahamas, north of the Caribbean Sea, and on the Caribbean's Puerto Rico, Cuba, Antigua, and other islands are testimony, through their artifacts, to a pattern of living that included ballparks, round thatched-roof dwellings, and a communal life that led the women to yield to the Caribs, although some scholars believe they never learned their conquerors' language.

The first tribes made their way from Venezuela's Orinoco River, north and then west from island to island. Others may have come from the west from settlements in Central America, and from the north. Peaceful tribes were conquered, first by the Caribs, who destroyed the gentler culture with their more aggressive ways, and then by the Spaniards who used Arawaks brought from Aruba for arduous field work in their settlements on the Dominican Republic.

As thirteen-year-old Andre told me who built what and why, he slouched at the feet of Christopher Columbus. Columbus stands firmly, as he has since the French cast him in bronze in 1837, on Plaza Colon, outside the buttery-beige Cathedral de Santa Maria la Menor, in the old city of Santo Domingo, the capital of the Dominican Republic.

And Cristobal Colon, as he is known in Spain, began to weave a colorful tapestry of European-Caribbean culture when he arrived on the north coast of Hispaniola (La Española) in 1492, after first landing in the Bahamas. On his second voyage, in 1493, Columbus returned with fifteen hundred men in seventeen ships, sighting Dominca on November 3 and noting—and naming—St. Martin, Antigua, Guadeloupe, Montserrat, Santa

◀ *On Barbados, The Codrington estate is now a boys' college; other plantation houses are museums, restaurants, or private homes.*

Cruz (now St. Croix), and Puerto Rico (rich port), which he called San Juan. After establishing a settlement at Isabela on La Española (which we know as Hispaniola, the island shared by Haiti and the Dominican Republic), the voyage continued on to Jamaica, where his ships wrecked east of Runaway Bay.

On his third voyage, with six ships in 1498, Columbus found Trinidad and the coast of South America, where he explored the mouth of the Orinoco. On his fourth voyage, in 1502, he sighted St. Lucia, before he went on to the riches of Central America.

Santo Domingo is unique, as a thriving twentieth-century city that has grown, like barnacles, on the fringes of a sixteenth-century core. To stroll along Calle de las Damas in the golden light of afternoon, as sixteenth-century ladies did, is to walk through history. Following a street plan of the early 1500s, many structures have been rebuilt in the style of that time, using limestone from original quarries. Others have been restored, and all are revitalized to bring the past into the present.

Santo Domingo has its counterpart in Puerto Rico's San Juan, spawned from the Dominican Republic settlement. Authentic to its time because the fort-protected peninsula made expansion on the three water-locked sides impossible, the historic buildings of Old San Juan nurture culture. The Dominican Convent is a historic building that hosts exhibitions by Puerto Rican artists; the gemlike museum of famed cellist Pablo Casals nestles in a contiguous building; and dozens of seventeenth-century buildings hold museums, boutiques, cafés, and art galleries in their carefully restored locations on the narrow streets of the old city.

La Fortaleza, built in 1540, continues to be headquarters for the island administrator—governor of the U.S. Commonwealth who is elected by the Puerto Rican population. Its neighbor, Casa Blanca, a home built for Ponce de Leon, who went from here to Florida, is a museum by day and the site for occasional outdoor concerts. And the town's many plazas host festivals and fêtes, often linked to saints' days on this largely Catholic island.

Although the Spanish came first, leaving behind a legacy of language, customs, art, and architecture, they are by no means the only Europeans to make a permanent mark on the region. Dozens of forts bear testimony to the importance the Spanish, English, French, and Dutch put on the area. This is where they fought significant sea and land battles during the seventeenth and eighteenth centuries while they strove to claim the best parcels among the new world discoveries.

Brimstone Hill is perched on a limestone bluff on the west coast of St. Kitts, with a view that includes St. Barthélemy, Sint Maarten, and Nevis. It has its echo at the Citadelle on Haiti's north coast, where hundreds of Haitians lost their lives between 1805 and 1820 while building an impregnable bastion against the French, on orders from Henri Christophe, Haiti's first king.

Fort St. Louis, on the waterfront of today's Fort-de-France, protected the harbor for the French on Martinique. Fort Charles, now part of a modern hotel, stood watch on the southern rim of Bridgetown, Barbados. Fort Young, built onto the bluff overlooking Roseau, is masked by a hotel on Dominica, while that country's Fort Shirley, in a 260-acre national park on the Cabrits headland north of Portsmouth, houses a maritime museum. Shirley Heights on Antigua, built for a British garrison, commands a bird's-eye view of English Harbour, where the British Navy's Caribbean fleet was based. Admiral Nelson gave his name to the dockyard, now restored and alive with yachts.

They skirmished on the high seas, but the British also settled several islands from Jamaica to Trinidad, including Antigua, Barbados, St. Kitts, St. Vincent, St. Lucia, and others. They planted sugar cane, creating plantations punctuated by the Great Houses that have become elegant private homes, lovely inns, romantic restaurants, or gentle museums where afternoon tea is served on the terrace in the shade of a cottonwood tree.

They brought Georgian architecture into the Caribbean, where local craftsmen adapted it to the warmer climate with balconies on buildings, a roofline to deflect the sun's warmth, and louvered windows to open for tradewind air-conditioning (and close when winds are strong). Furniture styles from the home country were adapted for tropical use with woven cane that lets welcomed breezes through the chairbacks.

The French, who set their sights on settlements in the West Indies, mingled more than their European colleagues with the Caribs and the Africans who were brought from far-off shores to cultivate the cane and other crops. From France came the language, the créole customs, and a recipe for life that leads to style, spices, and skilled preparation of island staples that dress the tables at mealtimes and delight the palate.

Dutch ways—neatness, a keen business sense, a style of fair play—are very much a part of the Netherlands Antilles, not only with the sun-washed, gabled buildings that border streets in Curaçao's Willemstad, but also with the Indonesian food and warm-weather customs brought from the Dutch East Indies.

Scandinavians, too, set their sights on the West Indies. The Danes settled the U.S. Virgin Islands, which they owned until the early twentieth century, leaving forts and architecture, as well as street plans, in the towns of Christiansted and Frederiksted on St. Croix, and in Charlotte Amalie, the group's capital on St. Thomas. Swedes settled St. Barthélemy, giving the tiny, U-shaped capital its name—Gustavia—in honor of the Swedish king, and its people their fair complexions.

And so it is that Columbus's followers—from pirates to plantocracy, Spaniards, French, English, Dutch, Danes, and especially the Africans, Chinese, and Indians brought to work the plantations—carried fragments from their home countries to weave into the rich tapestry on these sun-struck shores.

The spice of the islands comes from many sources. It is not just the Keshi Yena, a fat, stuffed cheese shell that melts into its seasoned filling. Or the rijsttafel that early Dutch settlers

Dominica is etched with waterfalls, creating myriad pools such as the Emerald Pool in Morne Trois Pitons National Park. ▶

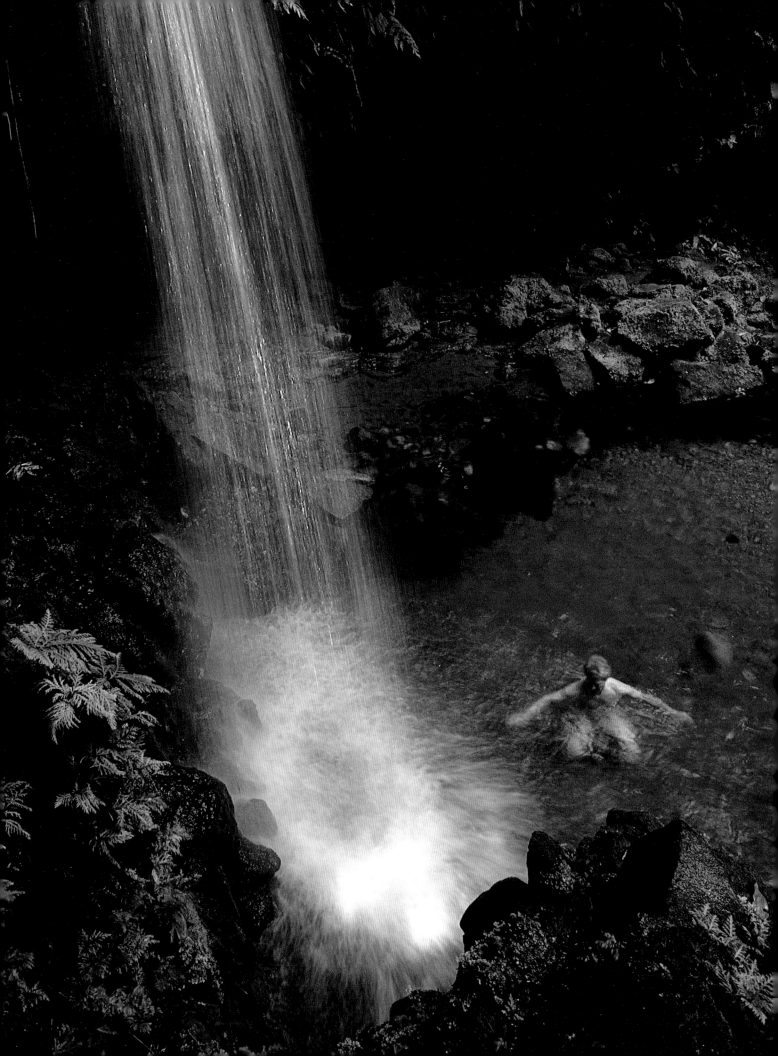

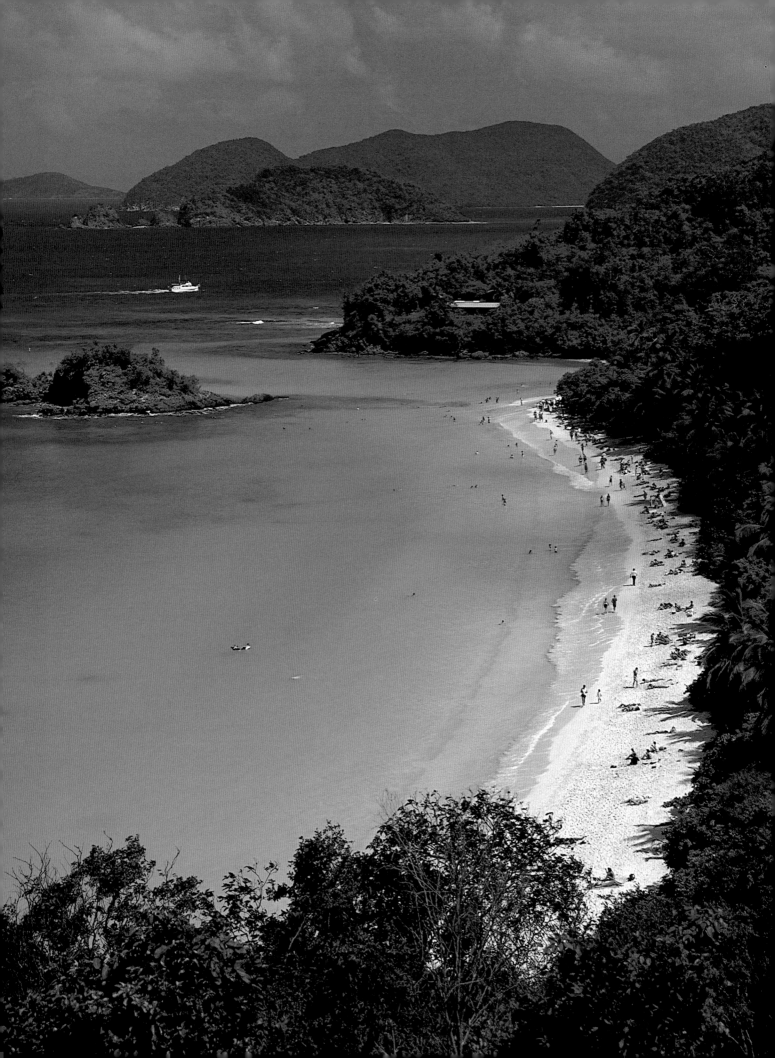

brought from their East Indies to the similarly hot climate of the West Indies. Or the pepper sauce that looks innocuous, but can send tears cascading down your cheeks when it sears your throat with its fiery essence.

The spice of the Caribbean is all of these and much more. It is thick, mud-green callaloo soup, piping hot and pungent. And it is peppery stuffed crab backs, using the land crabs that skitter across the road and around their hole-in-the-ground homes, lured out on dark nights by a flame torch—or a flashlight, if you're rich enough to have one. It is mountain chicken, as the large frogs of tropical forests are called when they appear, cooked and savoury, at the mealtime table. And it's curried goat.

It is lambi, with bits of conch made tender by careful pounding, perhaps between shell-and-stone on the beach. The shellfish is brought ashore by fishermen who dive deep to yank them off the ocean floor. And it's blaff, a fish stew served on the French islands, where cooks simmer the fresh catch in pieces, with kitchen herbs and spices. Blaff is best when served with crusty, warm, fresh-baked bread—and wine.

Grenada calls itself the "Spice Island," for the nutmegs, mace, and other seasonings grown on its hills and exported to provide hard currency for its coffers. But spices have been important crops on many islands, dating from the time when seventeenth- and eighteenth-century travelers brought them home to give flavor to the best tables of Europe.

And they continue to be important. Memorable places are where the cook serves at a few tables on her porch, at a shack just off the road. Or by the clear Caribbean, at an open-to-breezes bistro, where you can dress in your bathing suit and use the sea as your finger bowl. Or at a local gathering spot, perhaps a rum shop, where you can order "Ti punch" with the fishermen.

"Ti punch," like many rum drinks, is hard to forget. Unique to the French islands, it is a potent mixture of strong rum, sweet sugar syrup, and a squeeze of fresh lime, properly served with a ceremony reminiscent of British high tea. It is sipped, while socializing—or simply daydreaming.

When sugar was the islands' main crop, rum was the extract from its fermented juices. And rum these days is an island staple, mixed, whipped, and cajoled—sometimes with fruit juices—into an assortment of drinks. Some think it's best simply served—neat—so you can enjoy the unique shade of gold, and the flavor that comes with each distilling style.

The essence of Caribbean life comes from more than the kitchen or the bar, however. It comes with the lifestyle. While some islands seem ready to leap into the twentieth century, others are content with their longtime traditions. Local produce yields the best meals, but it is also a fashion statement! It often appears as a "hat," on countryfolk who use their heads to carry home-grown provisions to and from the marketplace.

By way of contrast to a fête with complex recipes, consider the specialists such as Mr. Rodriguez, in southwestern Puerto Rico, who stands near his roadside table-board of pineapples, awaiting a passer-by. On the day I found him, he stepped toward me with the dignity of a maître d'hotel, offering a sun-warmed pineapple that perfumed my car when I cut it—and sent sweet juice down my throat when I bit.

Pineapples are a specialty on Antigua, Puerto Rico, and a few other islands, but fresh fruits and vegetables are piled in colorful pyramids along the country roads, as well as at marketplaces, on many islands. These are the riches of the islands, today's treasures, to savour on the spot—and carry away as memories.

For many in the Caribbean, music is the food of life. West Indians are born with melodies in their souls. Their movement is as natural as that of trees in the trade winds, set to motion at the first note of a lilting tune played on the radio or when two or three are gathered together and have a potential instrument at hand. "If Trinnies would put half as much effort into running their country as they put into their carnival, they'd have the greatest country in the world," a Trinidadian friend told me long ago. You have only to visit a 'Mas Camp, as the gathering spots for various carnival bands are known, to appreciate what he means.

When the Desperadoes play, their music fills the sky. It was after midnight when our van wound up Laventille Hill, in part of Port of Spain not on the usual tourist track. Warm light came from shacks along the roadside; faces dotted windows; and people hung against the walls, clustering like moths to flame around the doorways of rum shops. As we lurched along the snake-route up the hill, assorted rocks and ruts tried to scrape the underpinnings from the van. That was our only peril.

By November, dozens of panyards are already in full tone, practicing for Trinidad's pre-Lenten carnival, the granddaddy of all Caribbean carnivals—and an event mentioned in the same breath with Rio's pre-Lenten bash.

Although it is the Caribbean's biggest and best, it is by no means the only. Tradition places carnival as a final fling before the six weeks of austerity and penitence demanded by the Christian calendar, but practical considerations have moved Caribbean carnivals to other times. Jamaica has its in June, Antigua's is in August, St. Vincent's is in May, all held when tourism's demands are less and life allows for celebration.

During one spring on Jamaica, witches giggled with clowns, while Indians eyed parrots near the elevators in the lobby of one of Kingston's high-rise hotels. Within minutes, relationships were severed as children were sucked into the minivans that carried them to the start of the children's parade.

Although the concerts that are evening events draw hundreds of Jamaican adults and friends, this is the children's chance. It is their introduction to the ritual of fête that will be forever a part of their life, when folks of all ages, creeds, and skin colors from ebony to powder-white would weave and

◄ *The twenty-ninth U.S. National Park, on Virgin Islands' St. John, has coves with sand as fine and white as powder.*

wiggle on the sun-baked streets of Kingston, bringing laughter to their route through an otherwise sleeping-on-Sunday city.

Today's carnivals and fêtes take their cue from slave celebrations, which mimicked the grand quadrilles and other dances at the master's Great House. The slaves gave their fêtes special style, however, with African rhythms and pent-up exuberance. It was a time when music and pantomime were the most effective means for often-forbidden communication.

On a few islands, music takes on a life of its own, as is the case with steel bands on Trinidad. And on Jamaica, Bob Marley's reggae permeates the air, coming into full bloom during festival times around the island. On Puerto Rico, classical music sets the tone at the annual Casals festival in June, which fills weeks with symphonies and other events honoring the life of famed cellist, Pablo Casals, who left Franco's Spain for Puerto Rico—and died there in 1973.

On Aruba, St. Lucia, and several other islands, jazz festivals are prominent on the social calendar. The Dominican Republic has its Merengue Festival, when Latins move as only they can to a dance some say was created when President Trujillo had to dance with a stiff leg. His followers copied him—gracefully.

As for dancing style on many islands, the best choreography integrates events in the life of traditional village and plantation workers into smoothly orchestrated movement that tells a rich story. The Groupe Folklorique that performs for cruise passengers and at hotels does it best on Martinique. But the zouk, a musical mingling of Caribbean rhythms and créole words, livens discos and other dance depots on that island.

Just as the islands have different physical characteristics, one from the other, so also their musical tastes reflect each island's unique personality, in spite of a sometimes overwhelming layer of "Yellow Bird," reggae, and rap throughout the region.

Boat-building in Caribbean communities has always been more than a job. It has been a labor of love as well as a matter of survival. For centuries, boats provided the only link with the outside world. The birth of one was greeted with more enthusiasm, in some places, than a newborn child. The beachside christening was a fête beyond belief, when home-brewed rum and other potions joined souse, callaloo, fresh-caught fish and all the village folk for a festive day—or days.

The big and bulky "Friendship Rose" was built on Bequia and, when launched, was the only "dependable" transportation between that island and St. Vincent. Its coffee-colored sails fit like baggy britches, but the wind carried the sturdy hull through the seas with a steady motion unknown by modern motorcraft.

Crates of chickens, limes, Coca Cola, and other necessities took precedence over the few passengers bound for one of the outpost inns. The spanking breeze that whipped through the open channel added chop to the always lively seas—and an unanticipated saltwater shower for most passengers.

A lunge was the best way to board the "Friendship Rose." Gracefulness was quickly forgotten; survival took precedence. Wandering along the waterfront and asking was the only way to learn departure times. And as for luggage, without a spoken word, every passenger knew you didn't take much—unless you were a belonger or making a major house move. Arrival was an adventure in those days, but the new airport may eventually yank local folk into the twenty-first century.

Villagers on some islands—Dominica, the Grenadines, and others out of the mainstream—still burn-and-carve-out the straight trunk of the gommier tree to make sturdy canoes. And there are boat builders who still frame up their craft on shore, working tirelessly to coax soaked boards to the bow of the hull. If you have the chance, watch a skeleton become a boat, as plank after plank is bent by pressure, to be fixed to an appropriate strut, perhaps by a modern nail but often capped with a wooden plug. Although the technique is older than many old-timers remember, it may soon disappear in a fleet of fiberglass.

The Family Islands of the Bahamas can trace their sport of sailing back to 1898, when races were held out of Long Island. These days, that country's Bahamian schooners, sloops, and dinghies sail out of Georgetown, in the Exuma Islands, competing in the annual Family Island Regatta or one of many regattas for Bahamian boats. Many of the home-built boats sport oversized sails that look like sheets on a laundry line and a complement of crew that could sink a less-sturdy craft. But few people have more fun than the sea-doused competitors, for whom a spontaneous dunking can be part of the lark.

A counterpart to that race is the annual Carricou Regatta, held out of Grenada's satellite island on August 1, and other races such as those held from Anguilla's shores. One of the most popular annual sailing events is Antigua's Race Week, when boats converge from around the Caribbean, skippered by top international competitors as well as seasoned island folk.

The joy of the Caribbean is that anyone can sail. Proficient sailors charter in the British Virgins, fondly called the playpen for sailing folk, or in the Grenadines, where heavier seas surge between the several islands and prevailing winds are strong, or in any of the marinas that fleck deep coves on the islands.

Then there are the divers. Most mornings, Adam rows his home-carved boat toward the horizon. When he sets out from his beachside hut the goal looks far away, but the tiny offshore island looms larger as he rows closer. Once there, Adam sets his rock-anchor and free-dives—deep—to the nests of conch whose emptied shells he later plants by the side of his house.

While most of us will don scuba or snorkel gear before we free-dive, when surrounding seas are clear as crystal and colors range from aquamarine to sapphire, the temptation to get on it, under it, or at least in it, is almost irresistable. Islands are like that. Nothing less than total immersion satisfies—and then you can hold the experiences in your heart forever.

Snorkeling in the British Virgin Islands—or in numerous other sites throughout the Caribbean—is a never-to-be-forgotten experience. ▶

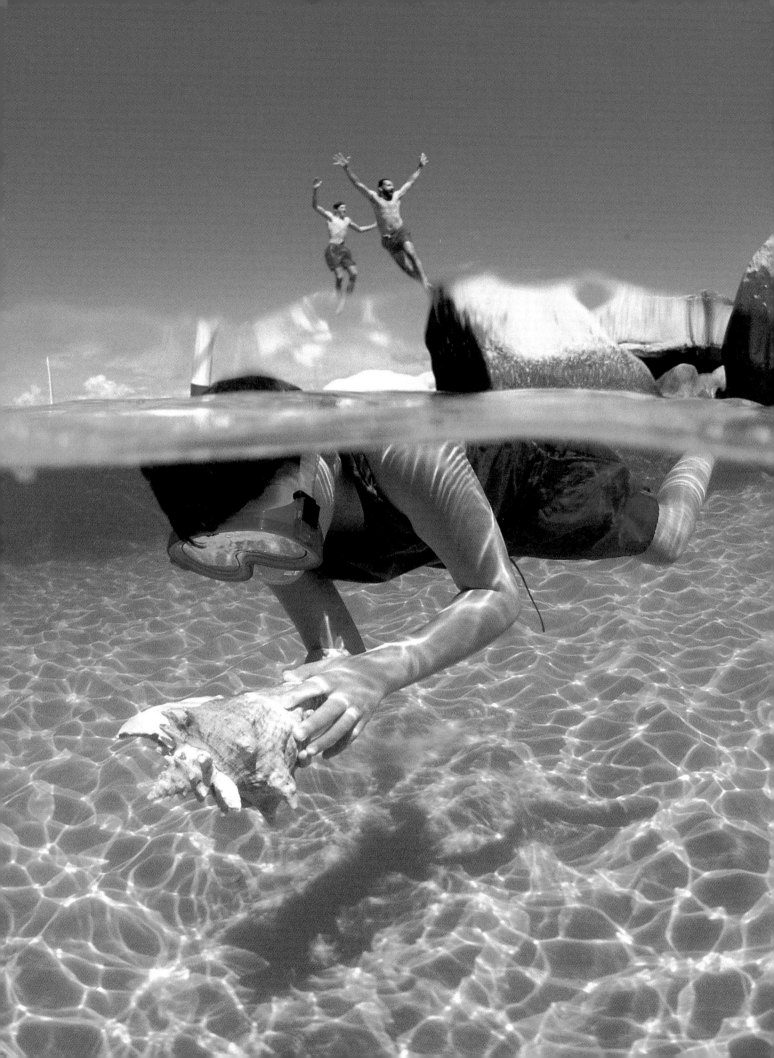

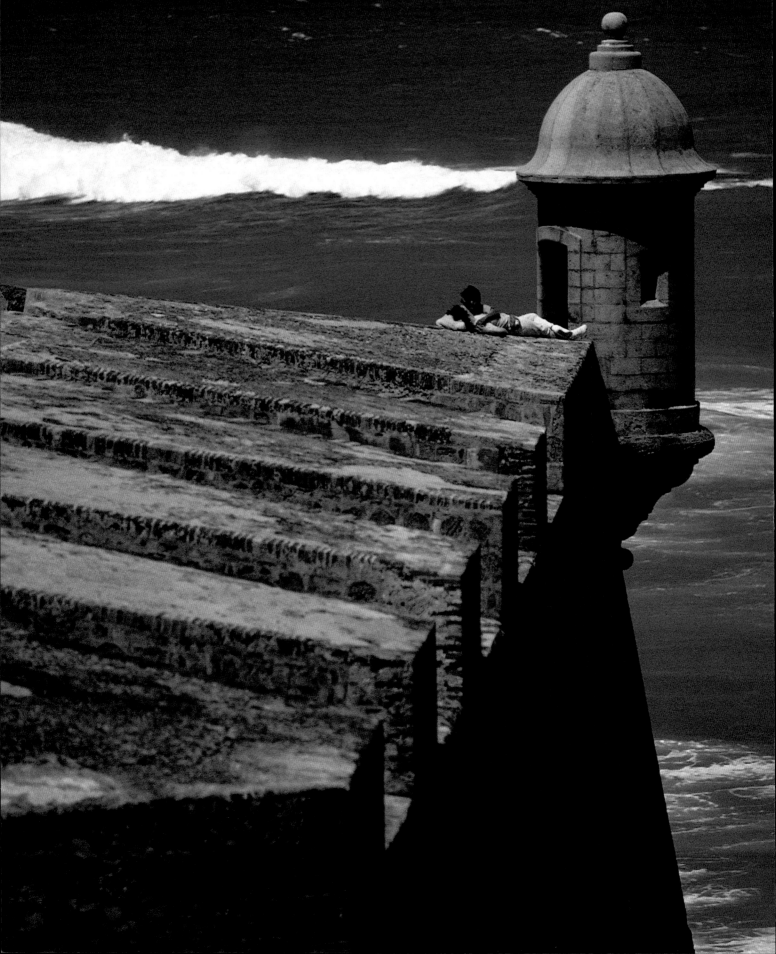

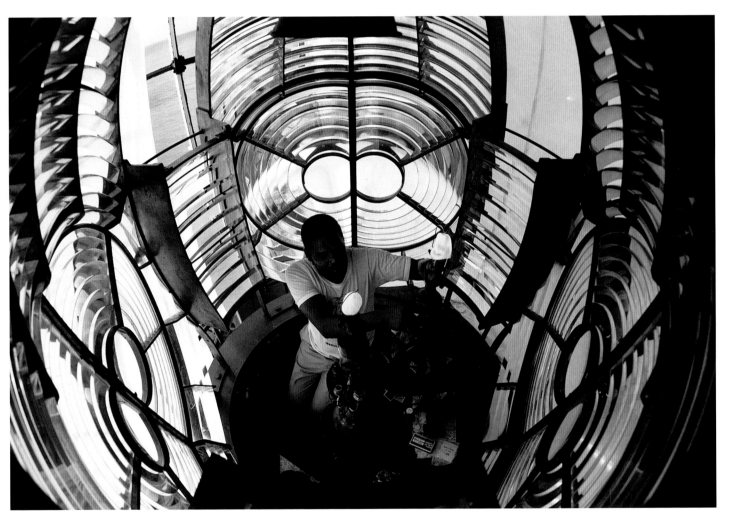

◄ To protect their settlement from English and French invasions, Spaniards built Puerto Rico's Fort San Cristobal in 1772.
▲ Lighthouses—like the one at Matthew Town on Inagua in the Bahamas—have guided ships through treacherous coral reefs since the 1700s. ► ► Port Antonio, near Jamaica's east end, has been a hideaway for luminaries over time, but its natural attributes are its continuing appeal.

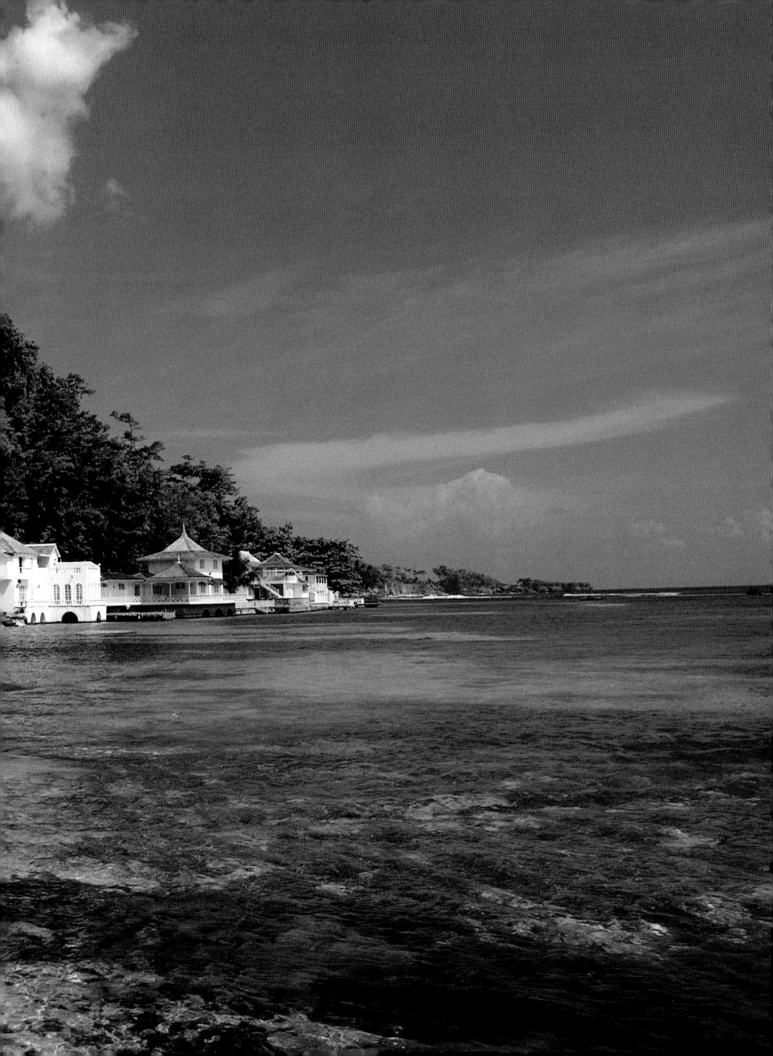

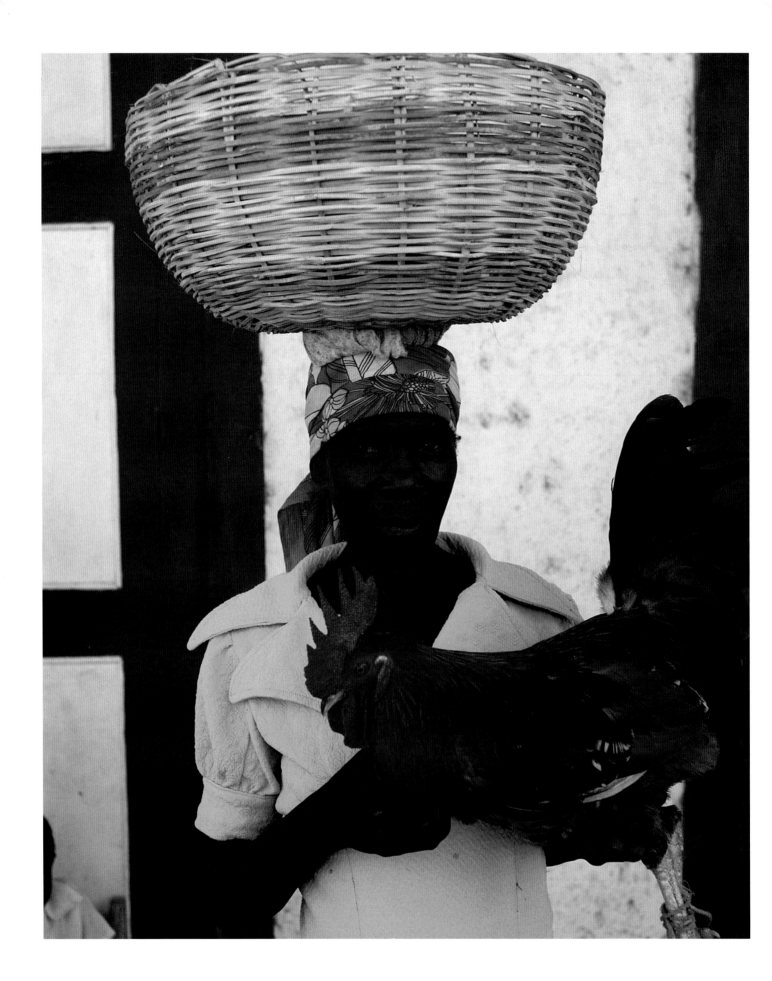

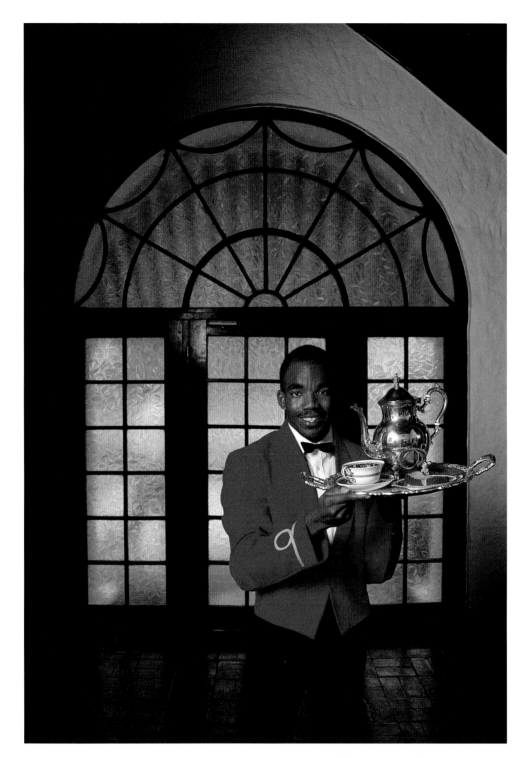

◄ Haitians who walk their produce to and from the market are known as *marchands;* they wear the "hat" of their trade.
▲ The British brought their custom of high tea, as well as Georgian architectural styles, to their Caribbean colonies. On independent Jamaica, where tourism is an important industry and a major employer, elegant resorts allow guests to sample a lifestyle seldom found in most people's daily lives.

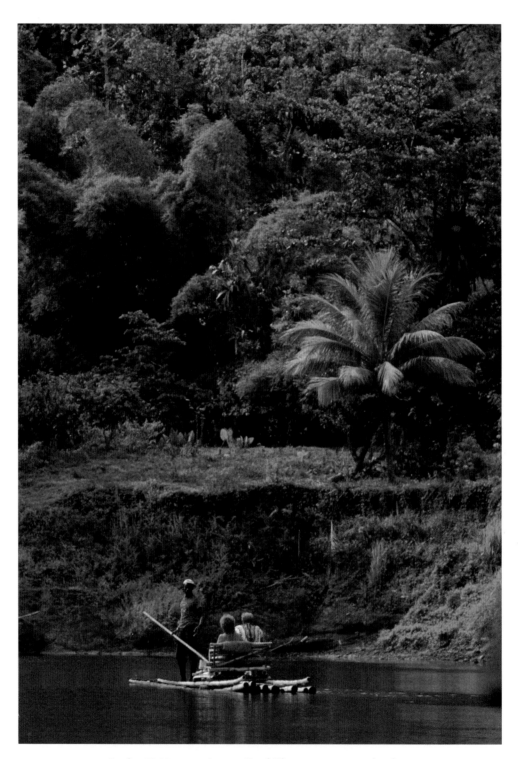

▲ In the 1940s, movie star Errol Flynn encouraged rafters to transport guests on their regular market journeys. ▶ Just as homes are decorated in the resident's taste, so hand-made fishing boats in Jacmel, Haiti, show their owner's style.

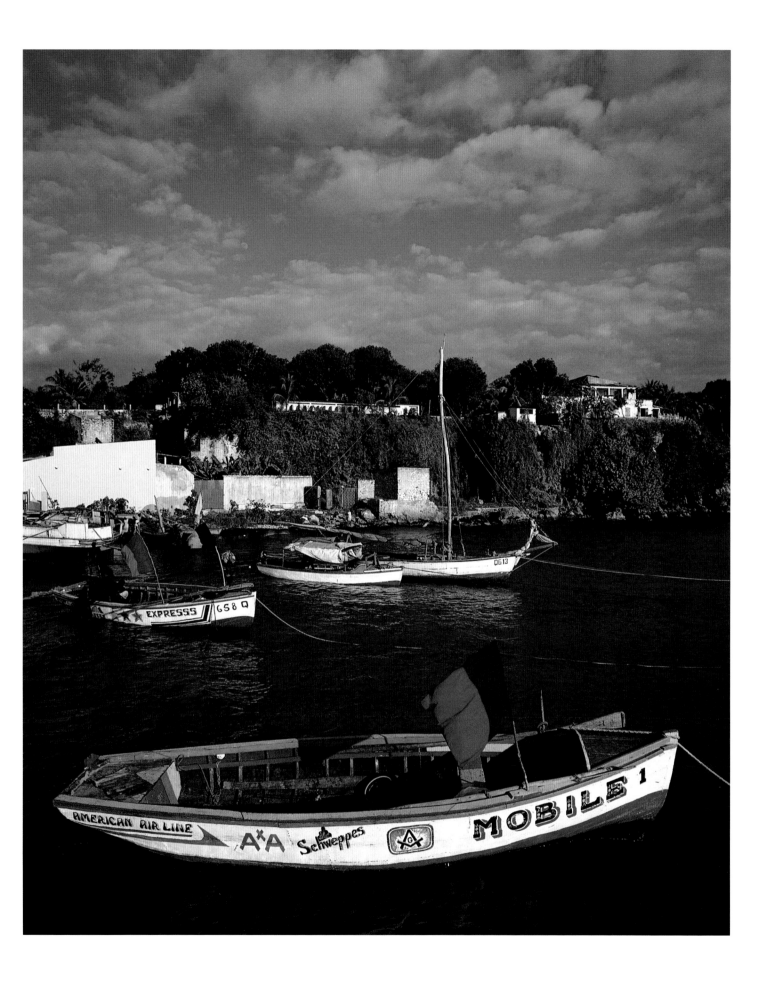

◄ Haiti's future depends on its young people, who struggle against overwhelming odds to build a viable life. ▲ Haiti became the first Black Republic when it gained its independence from France in 1804. Battered by the vagaries of world economics, along with the country's own political leaders, Haitians manage to eke out a living from their land.

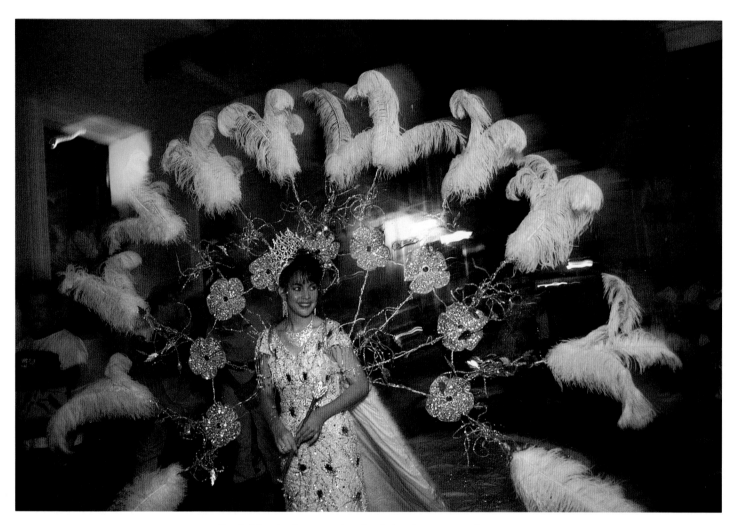

▲ Festivities in Puerto Rico hark back to Spanish customs, with elements gathered from what has been learned of the early Taino culture. ▶ Puerto Ricans make the most of their festivals and competitions.

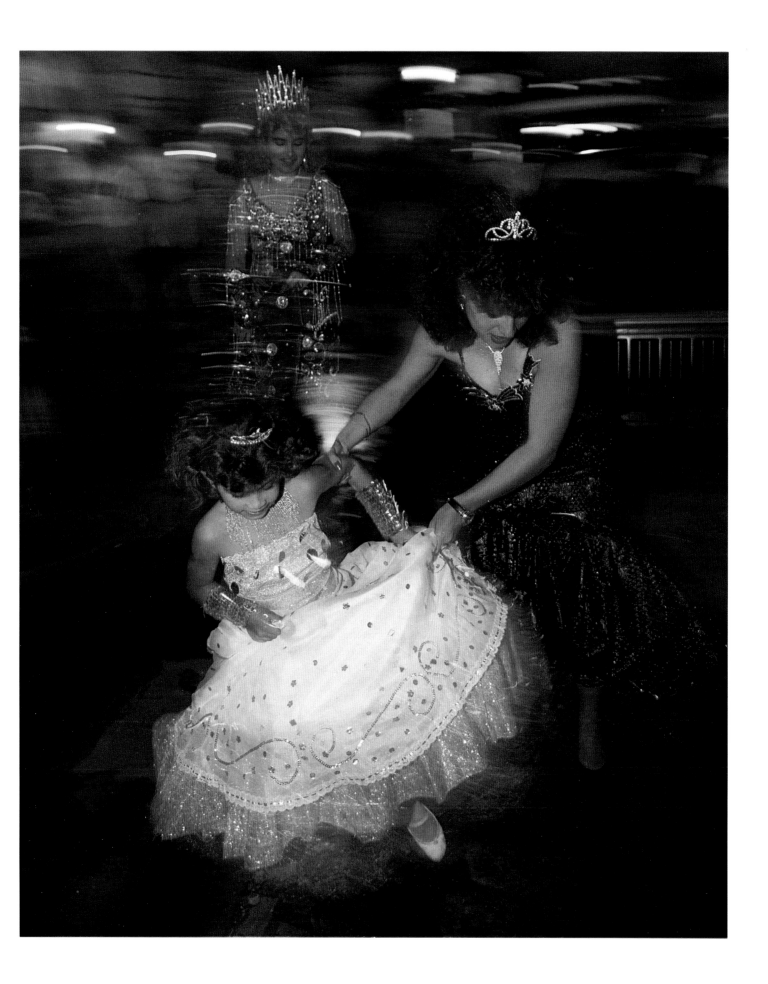

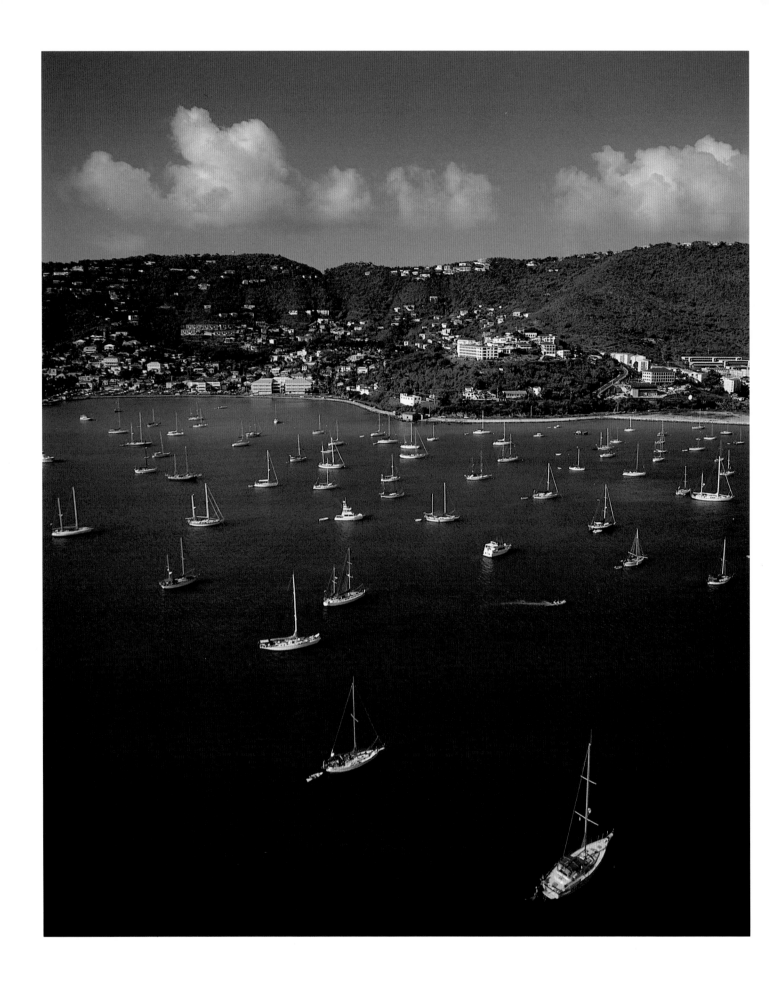

◄ Burgeoning Charlotte Amalie, capital of the U.S. Virgin Islands, dots land and sea with homes. ▲ Crystal clear waters and white sand beaches mark St. Croix in the U.S. Virgin Islands. Sailors for centuries have known safe haven could be found in any one of the hundreds of tiny coves and inlets that mark the numerous islands of the Caribbean.

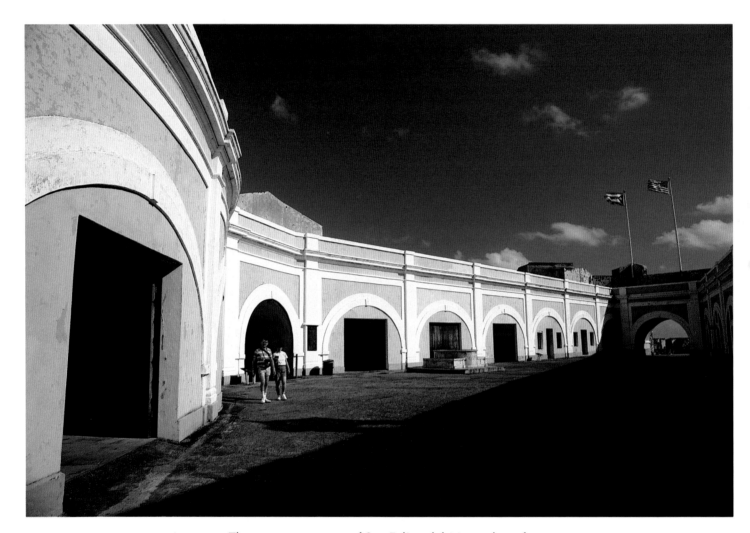

▲ The present structure of San Felipe del Morro dates from 1783, after extensive rebuilding and additions, most of which survived attack by Admiral Sampson's forces in the Spanish-American War. ▶ With walls rising 140 feet from the sea, El Morro fortress kept Old San Juan safe from the planned invasion by British forces led by Sir Francis Drake in 1595.

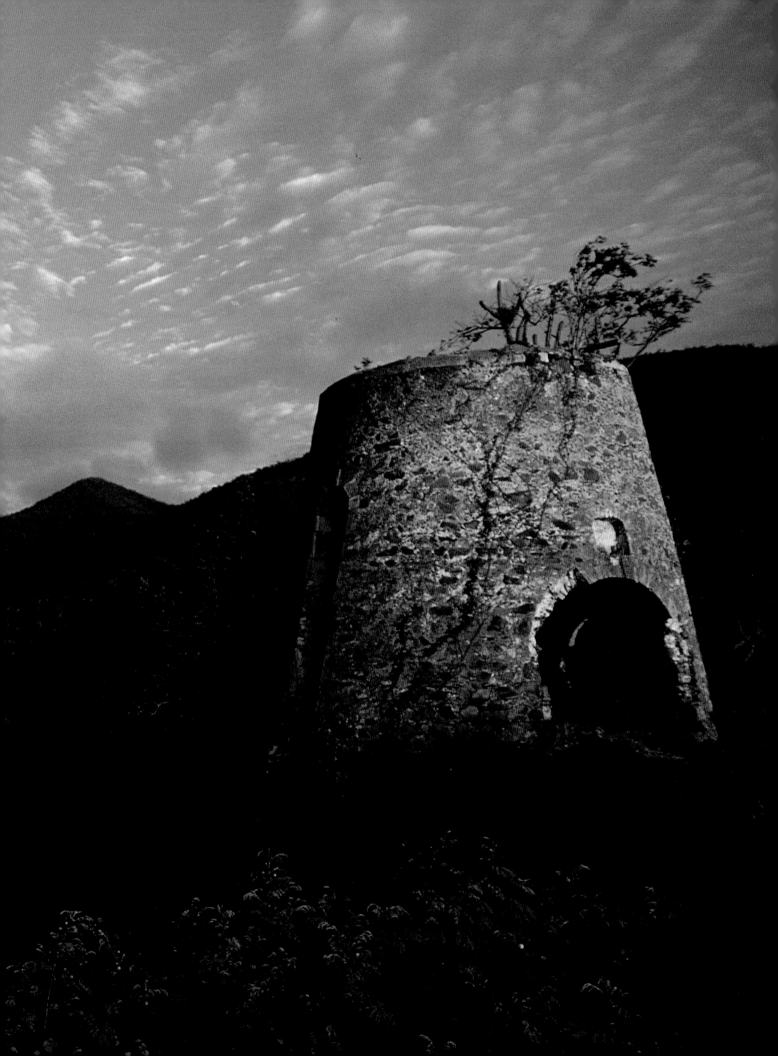

◄ Mill towers testify to the 1700s and 1800s when wind moved their sails and oxen worked the grinders at their base, as was the case at sugar plantations on St. John, U.S. Virgin Islands. ▲ The British Virgin Islands, known as the sailors' playpen, provide an ideal area for sailors. ► ► Undeveloped British and U.S. Virgin Islands recall sights Columbus might have seen when he sailed these seas.

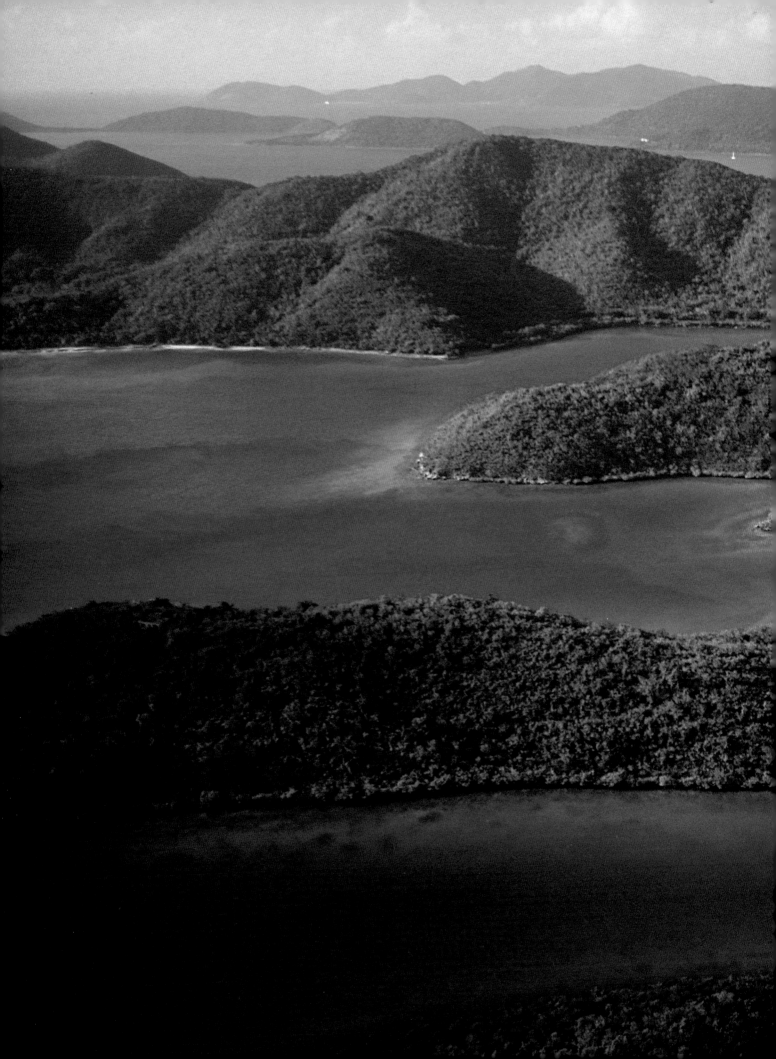

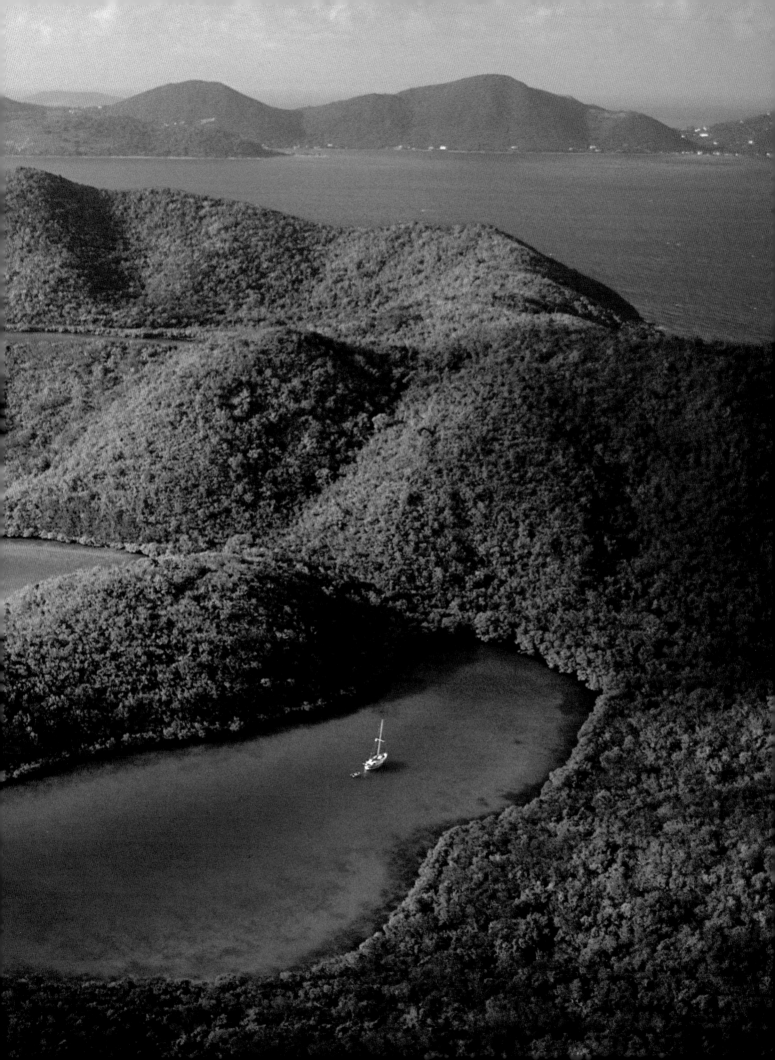

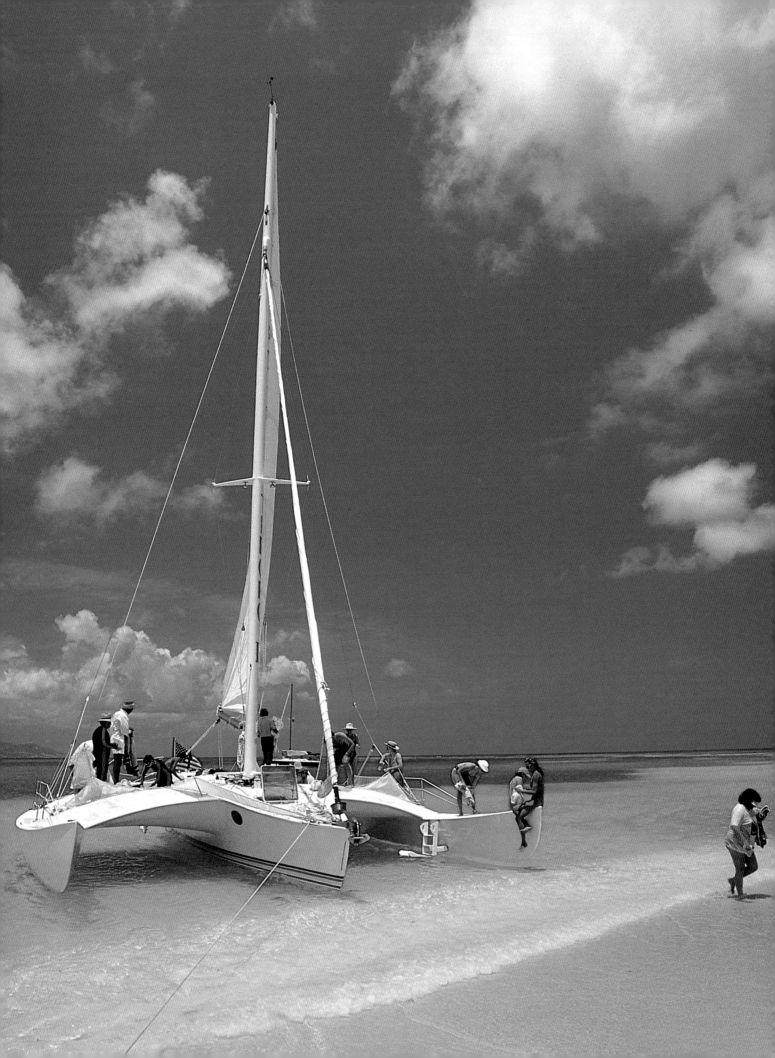

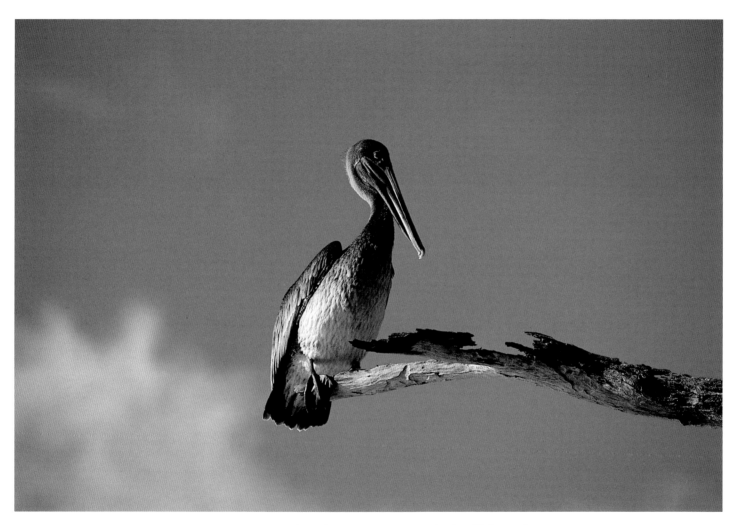

◄ Passengers of a charter trimaran make landfall on the powdery sand beach of Buck Island, off the coast of St. Croix. ▲ Brown pelicans provide entertainment, revving up their oddly-weighted bodies into flight and plunging from great heights to fish from the sea. ► ► Charlotte Amalie is a hive of shopping activity when cruise-ship vacationers and other travelers come to St. Thomas.

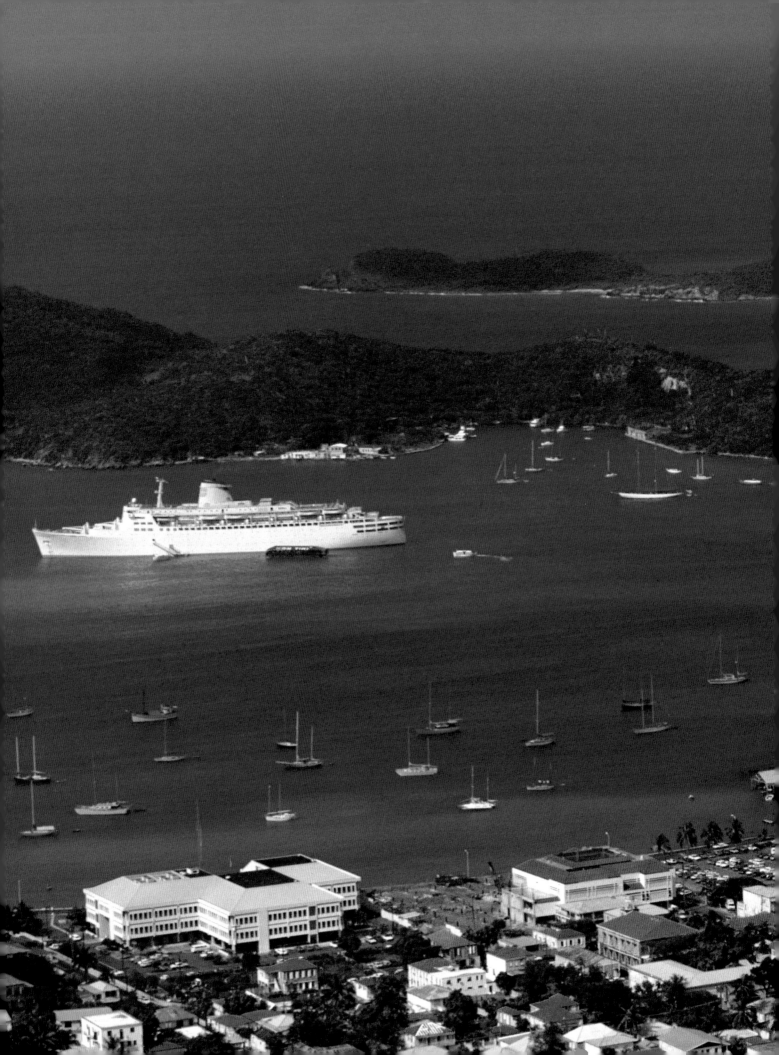

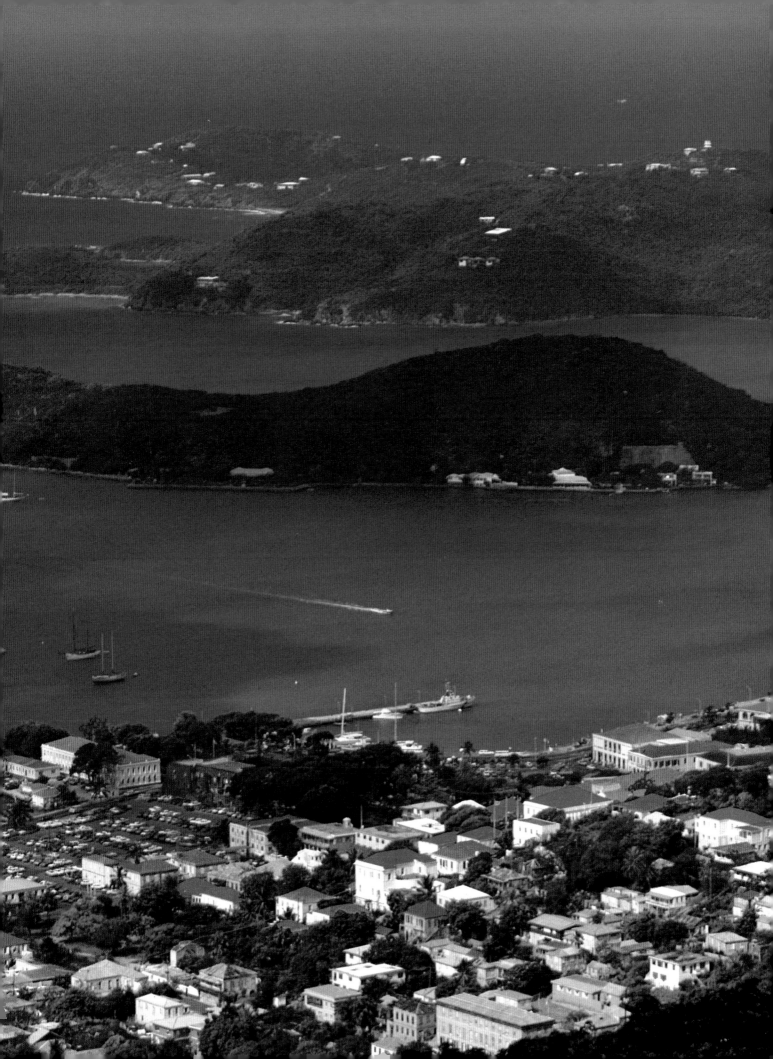

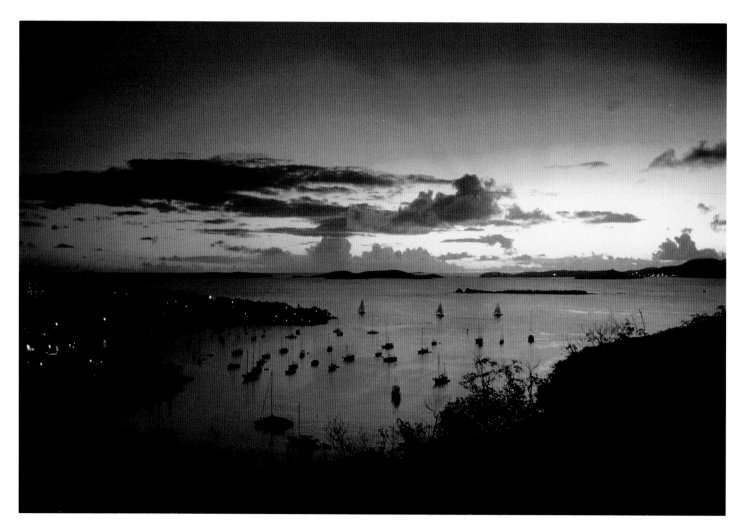

▲ Although modern comforts ease the daily routine, it is still the natural marvels that become addictive throughout the Caribbean islands. The island magic comes from a sunrise, a sunset, the whisper of the trade winds as they pass palm fronds and other flora, and the brilliance of a blossom in its sea of green foliage. ▶ Tranquility surrounds in a transparent sea off deserted Sandy Cay in the British Virgin Islands.

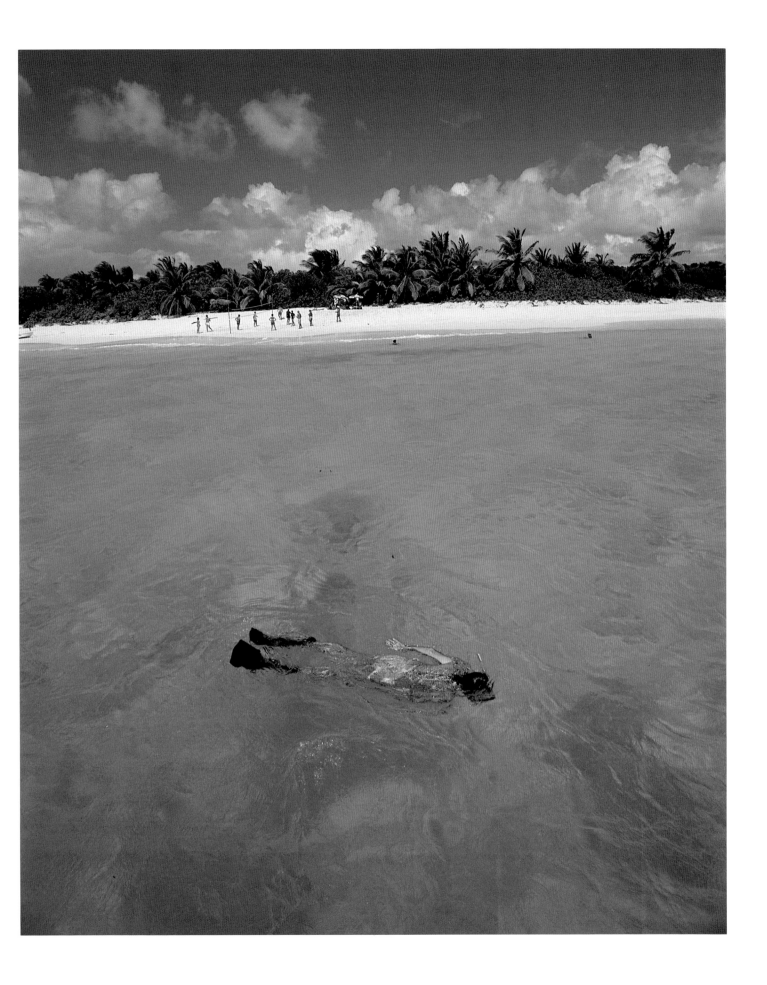

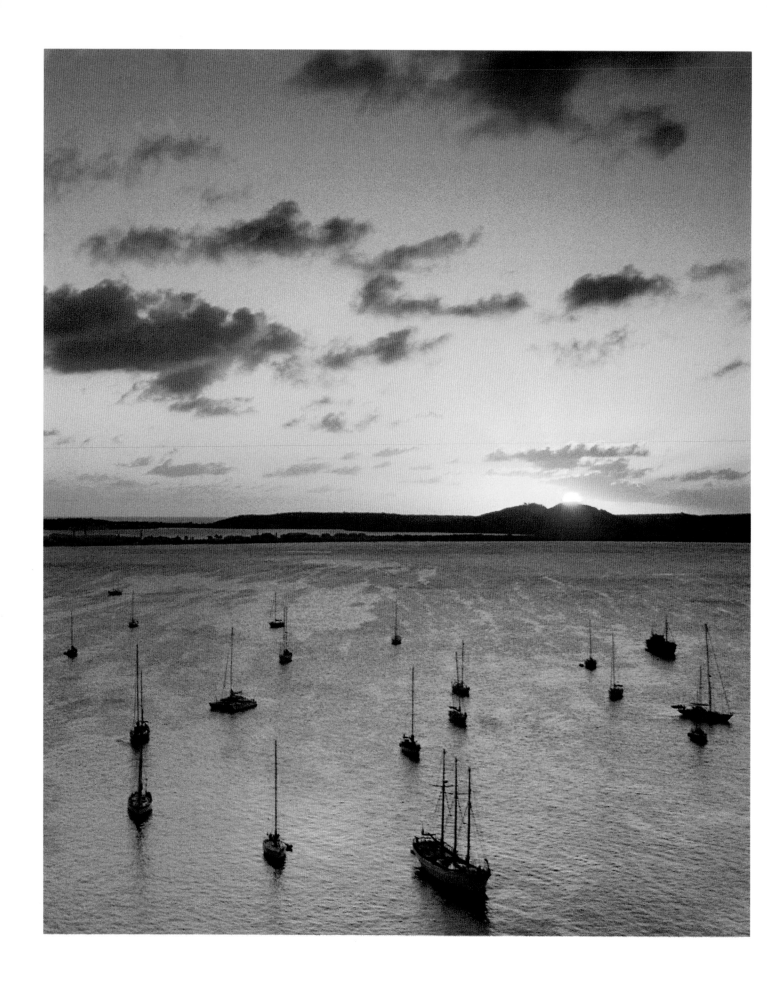

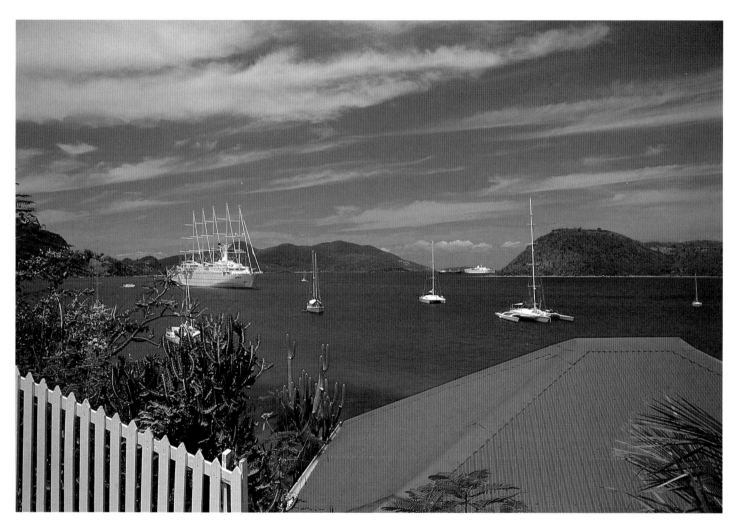

◄ Boats as varied as their owners become a community as sun sets over Marigot, the main town on French St. Martin.
▲ Yachts at anchor in the tiny harbor at Terre de Haut, off Guadeloupe, hardly hint at nineteenth-century naval battles between the British and French that made the building of Fort Napoleon necessary. The islands of Les Saintes remain—for now, at least—outside the mainstream of tourism.

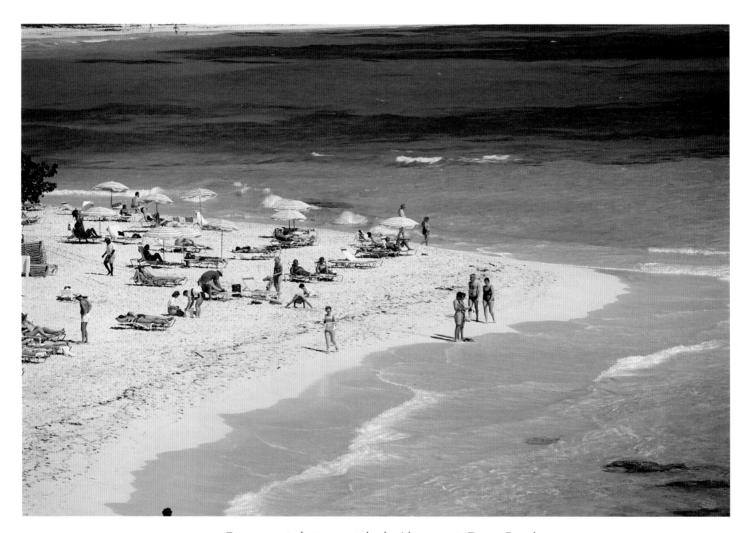

▲ Once remote but now etched with a resort, Dawn Beach, on the eastern shore of Dutch Sint Maarten, is a blanket of sand as soft as talcum powder. ▶ Reading the Caribbean seas is as crucial for yachtsmen today as it has been for sailors through the ages.

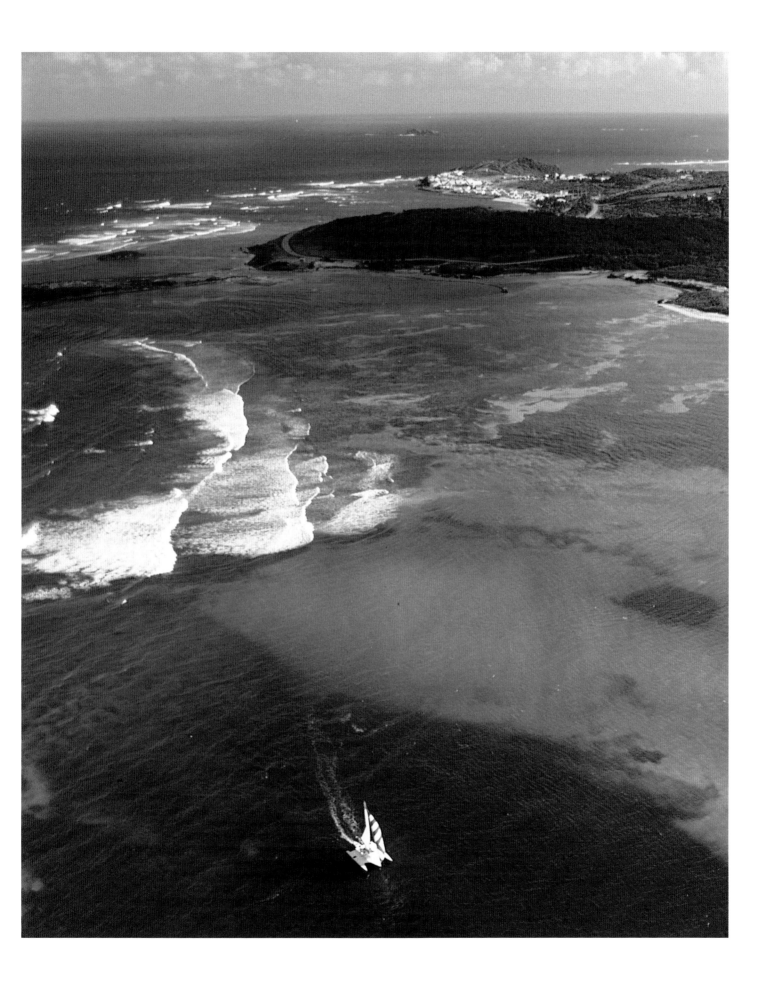

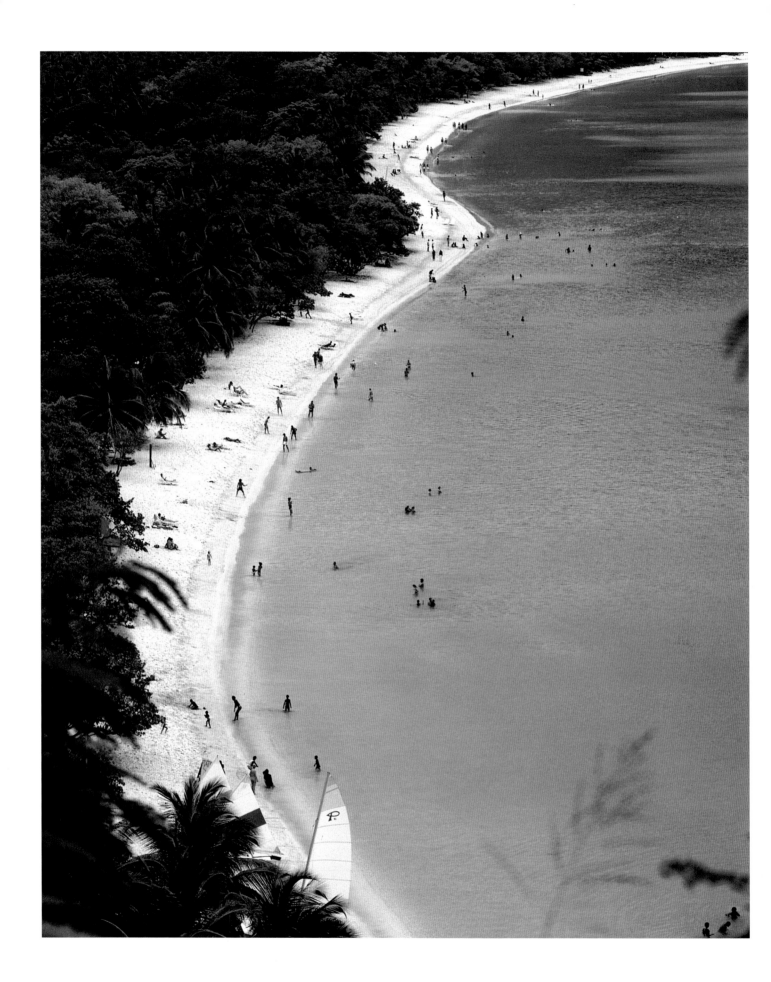

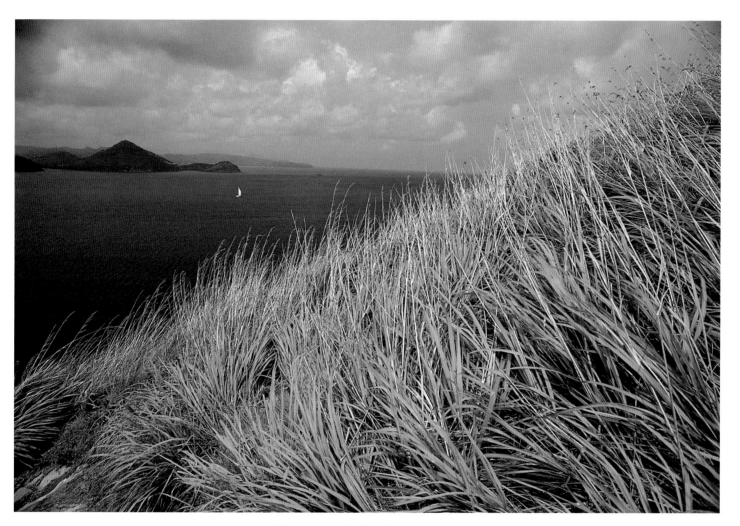

◄ In spite of a spate of development, Magen's Bay on St. Thomas remains one of the Caribbean's most beautiful strands. ▲ Pigeon Island, which became Pigeon Point when it was linked to St. Lucia by a manmade causeway, is now Pigeon Point National Park. With fortifications dating from the late 1700s, the area is popular for activities such as picnics, swimming, snorkeling, and scuba diving.

▲ Cafés, boutiques, and other gathering spots dot the border of Marigot's marina, creating a lively French seaside atmosphere unique to St. Martin. The area around the yacht harbor is as lively at nightfall as it is in the early morning when hot coffee and croissants are a ritual for many who set out on their yachts at dawn. ▶ Within sight, but so different, tiny French St. Barthélémy is chic and style-setting.

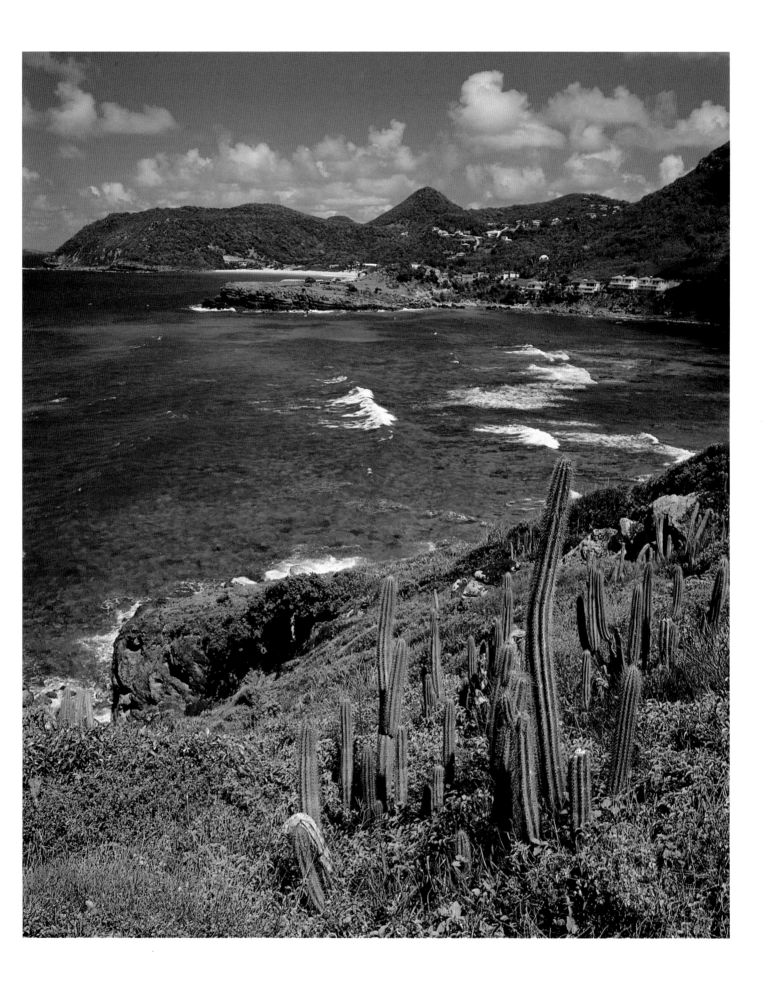

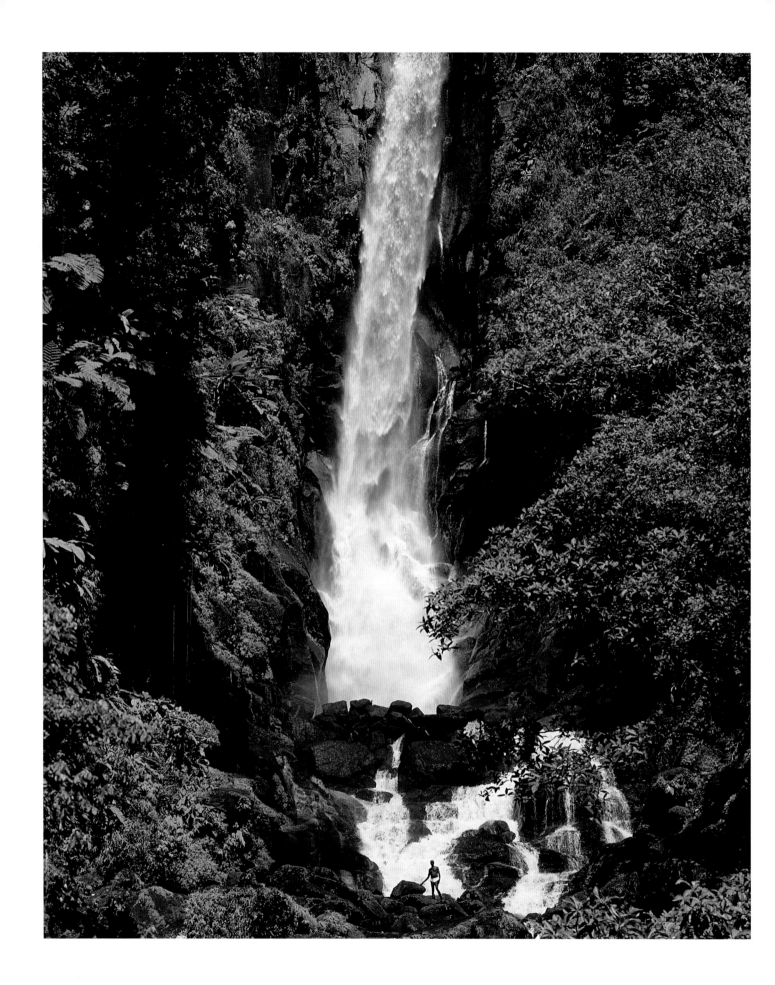

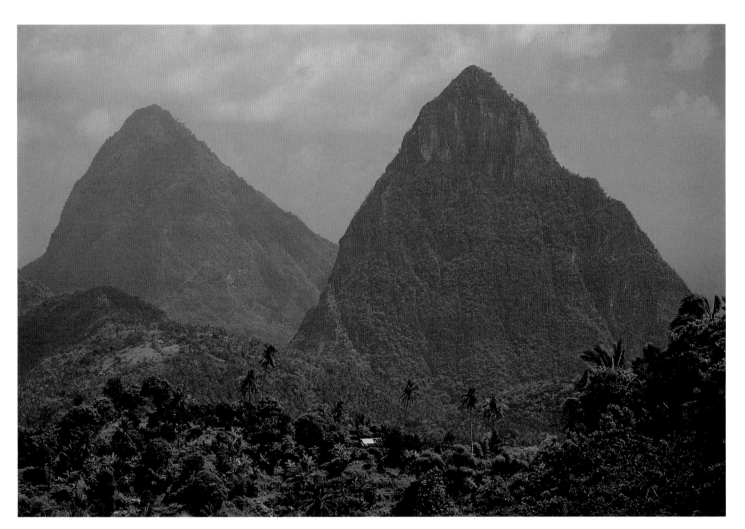

◄ In its verdant hinterland, Dominica's waterfalls surprise intrepid travelers who hike to find them. ▲ Though the shoreline between the Pitons of southern St. Lucia is now broken with an exclusive resort, the terrain stretching almost twenty-five hundred feet high is known only to experienced climbers who explore with knowledgeable St. Lucian guides.

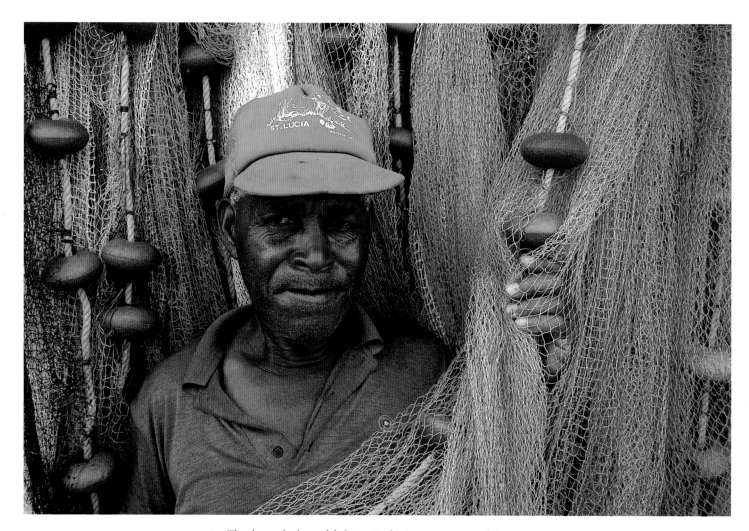

▲ The knowledge of fishing techniques is passed from one generation to the next; pride in his craft is part of an island fisherman's stock in trade. ▶ A landmark for sailors, the dramatic peak of St. Lucia's Gros Piton rises above the fishing village of Soufriere. ▶ ▶ The mountainous spine of St. Lucia is covered with verdant forests, which are crisscrossed by hiking trails and nature walks.

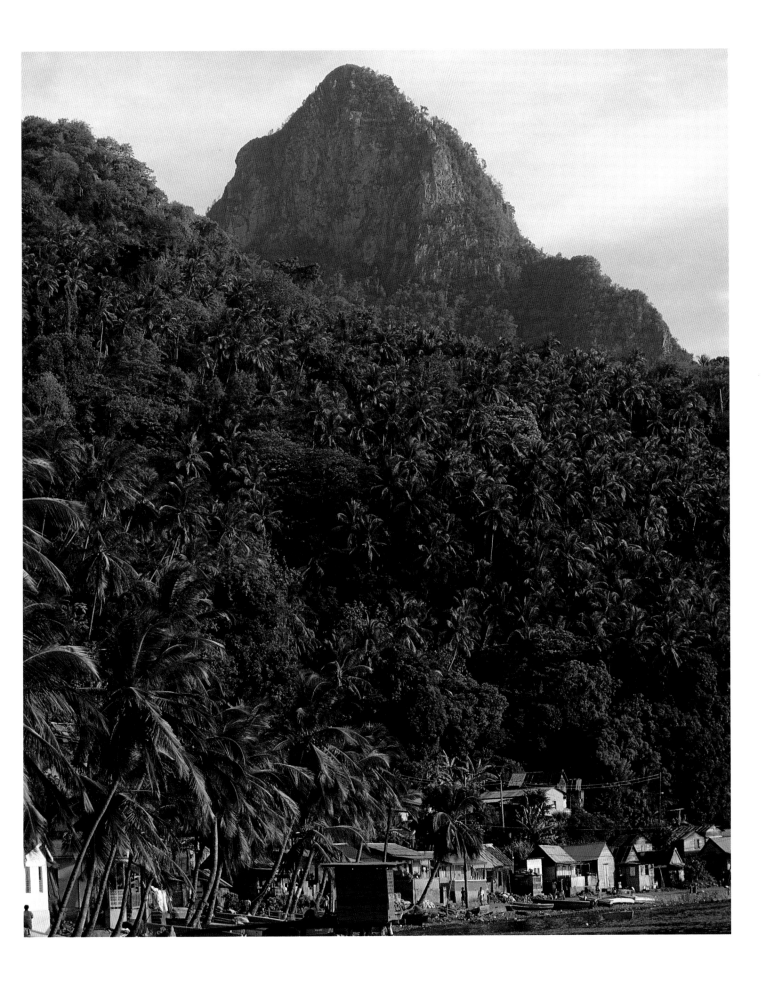

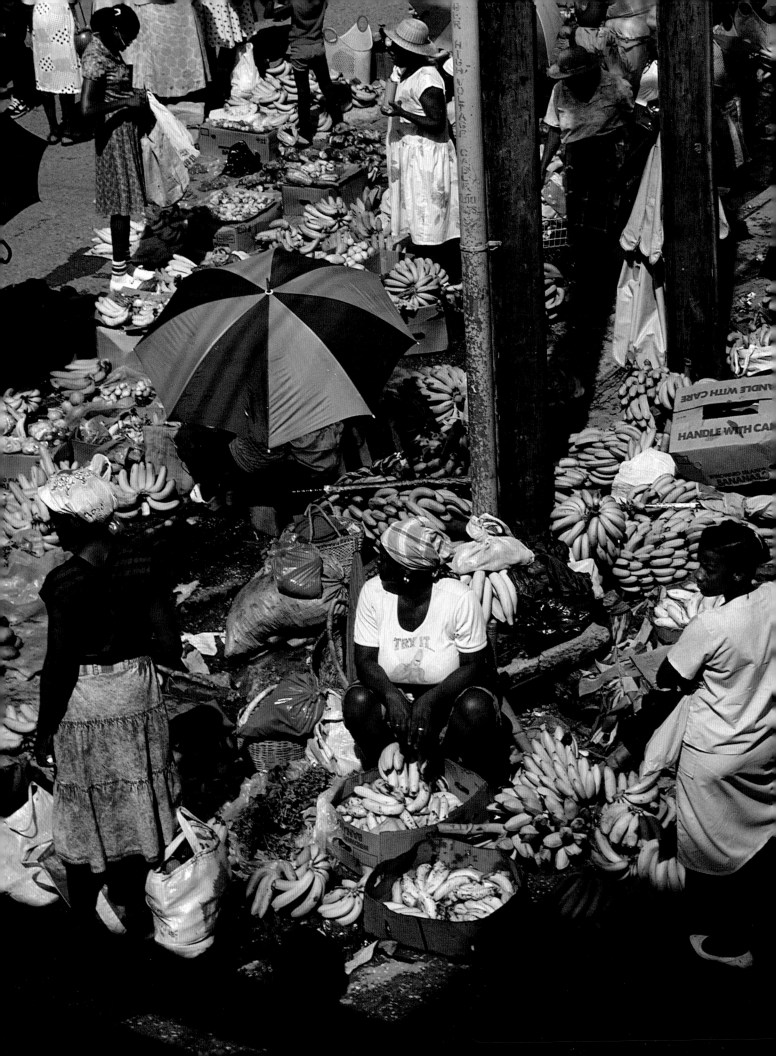

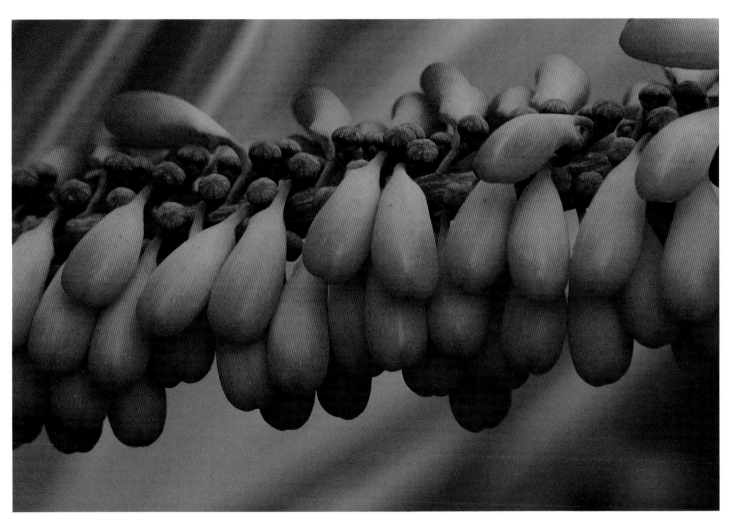

◄ The Saturday morning market in Castries, the capital of St. Lucia, is as much a social occasion as it is a time to trade wares and produce. For most visitors, markets provide an opportunity to walk into the life of the country. ▲ The natural colors of the tropical flowers and fruits add drama to the region's backdrop of sea blues and forest greens.

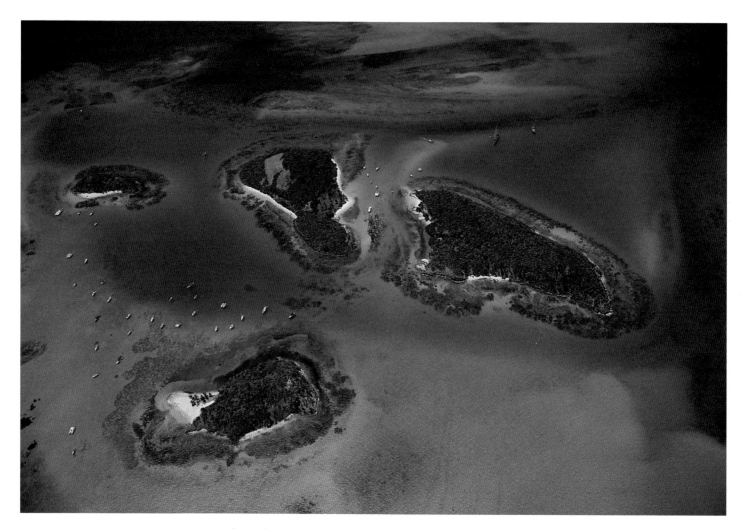

▲ The Tobago Cays, members of St. Vincent's Grenadine islands, are slowly changing, as the living coral that created them grows and modifies. ▶ Explorers came searching for gold, but spices brought riches to those who found the island of Grenada, which grows one-third of the world's supply of nutmeg. When mace, the lace cover of the nutmeg seed, can be removed in one piece, it commands the highest price.

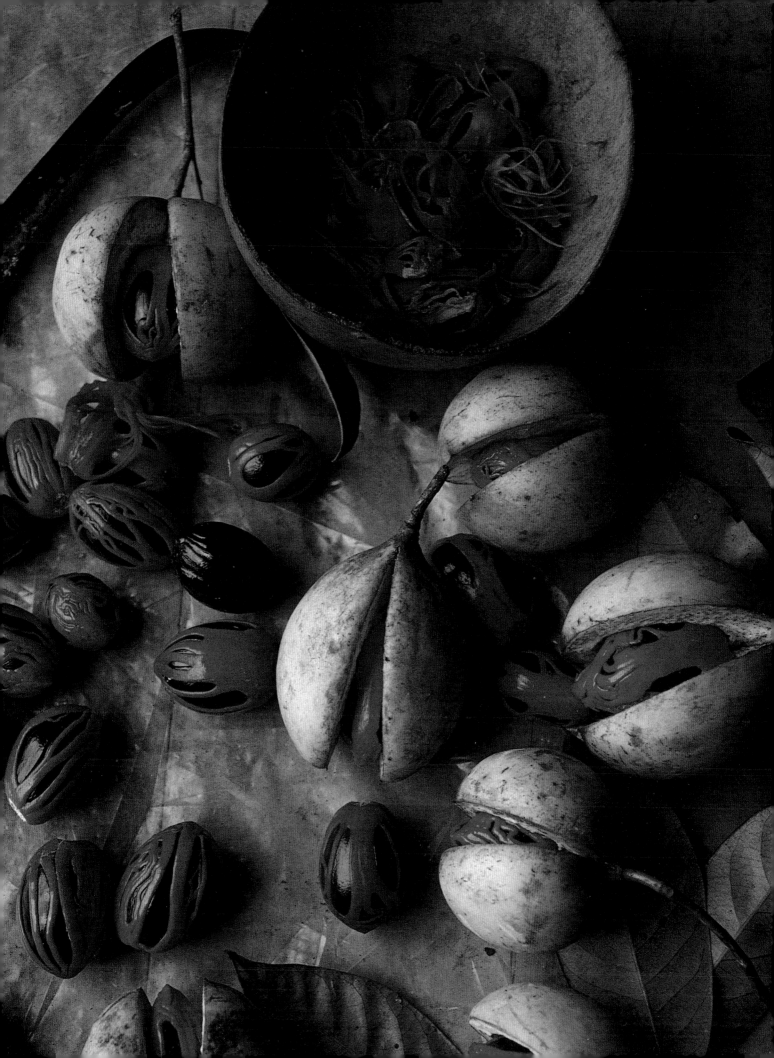

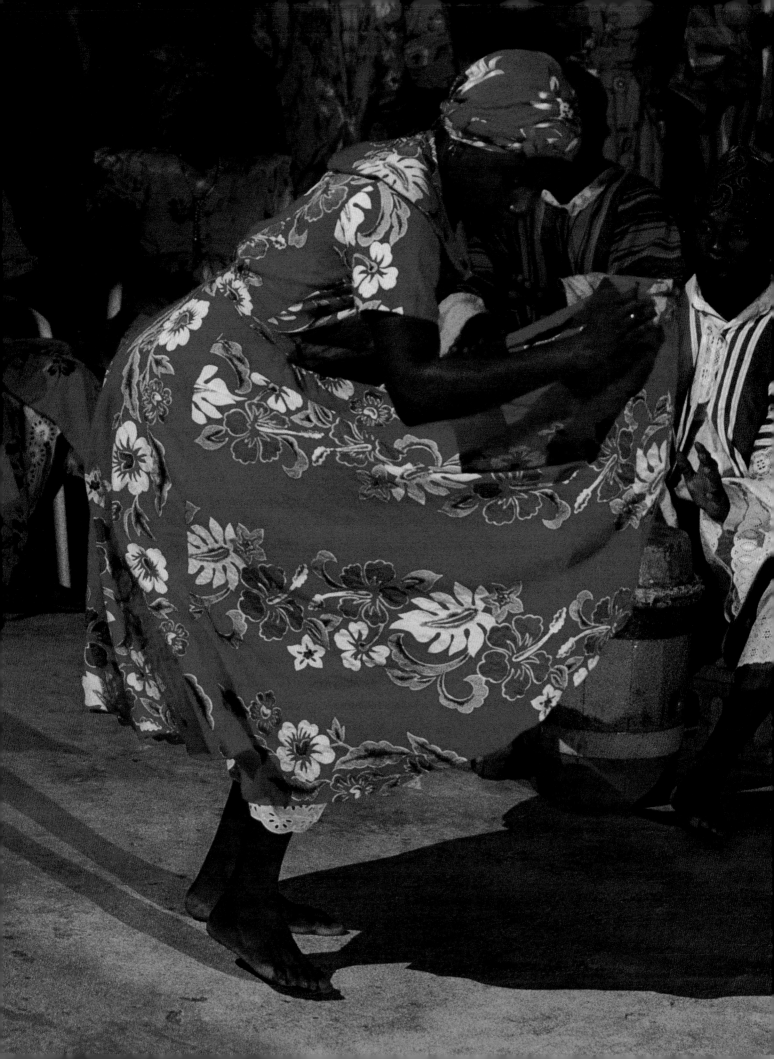

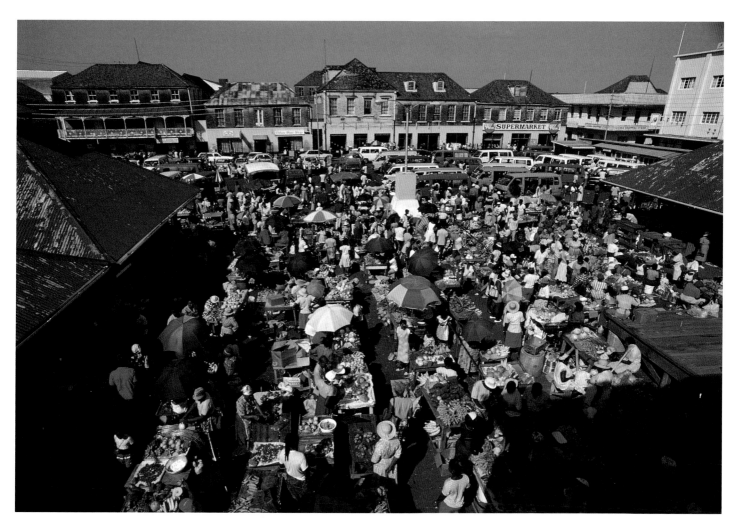

◄ Dances, tracing their lineage to African tribes and mimicking movements from European courts, are woven into the culture of the Caribbean. On Carriacou, one of the Grenadine islands, the pulsating Big Drum dance is performed at festive occasions. ▲ St. George's market is open throughout the week, but Saturday is the liveliest day. ► ► The Caribbean seascape varies from crystal clear to deepest sapphire.

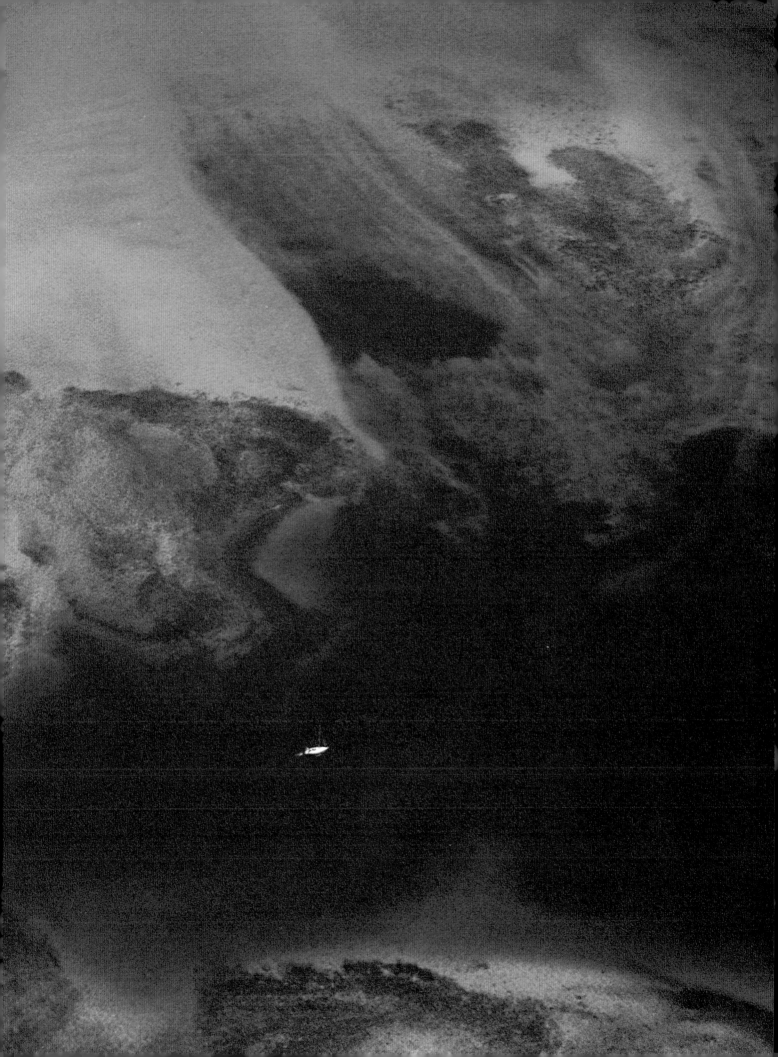

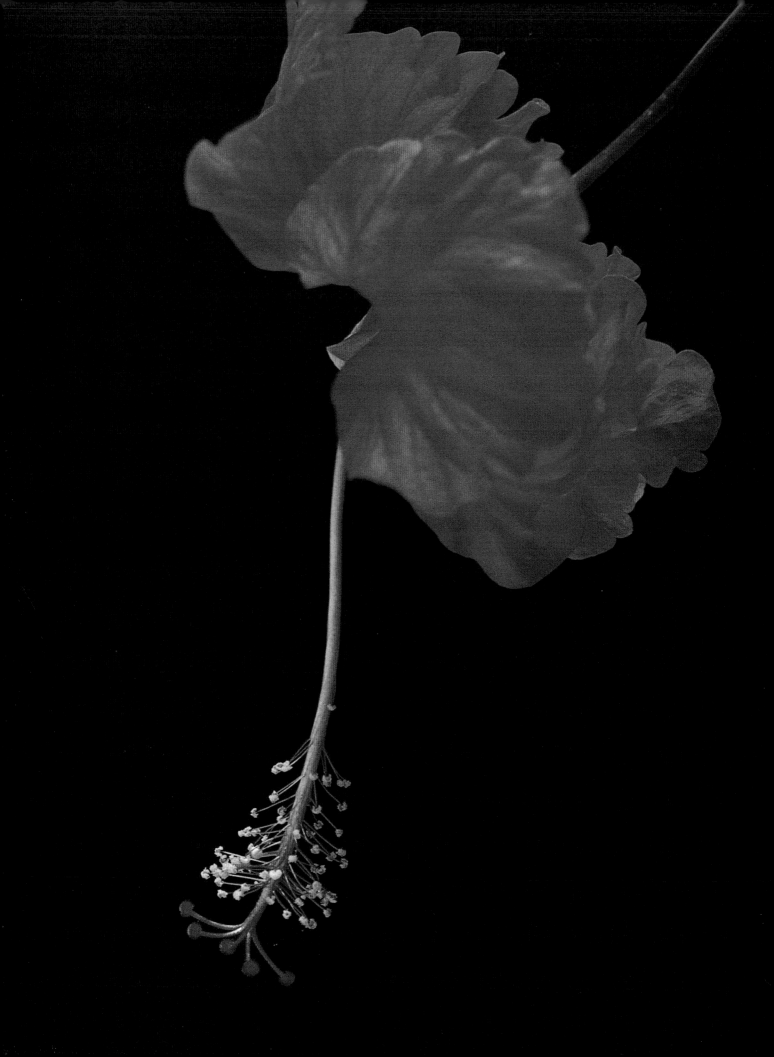

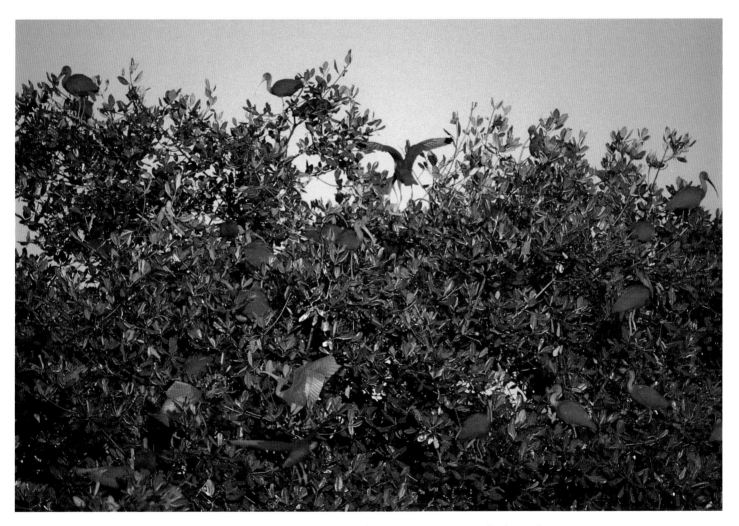

◄ Nature gave the islands their greatest assets—flashes of brilliant color, from the hibiscus and other flowers to the islands themselves. ▲ Nesting in mangrove trees, some three thousand scarlet ibis decorate the branches. ► ► The source of sustenance since time began, the sea is in the life of West Indians who look to it for food, a livelihood, and an avenue for travel. Only recently has it become a playground.

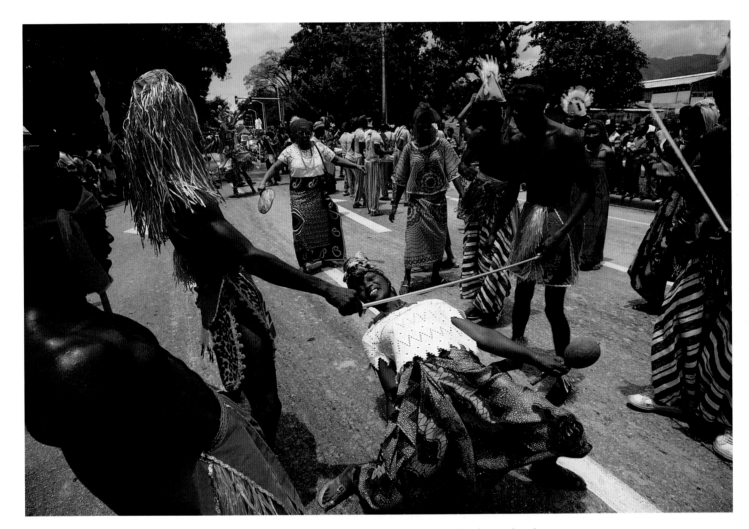

▲ Trinidad sets the region's pace for fête, whether it be the annual pre-Lenten carnival or any one of the many other dances and parades. ▶ Taking its cue from earlier times, the elaborate dress for festive times is months in the making and always speaks its own language. ▶ ▶ The Queen Emma Pontoon Bridge connects the two halves of the capital city of Curaçao, Willemstad, in the Netherlands Antilles.

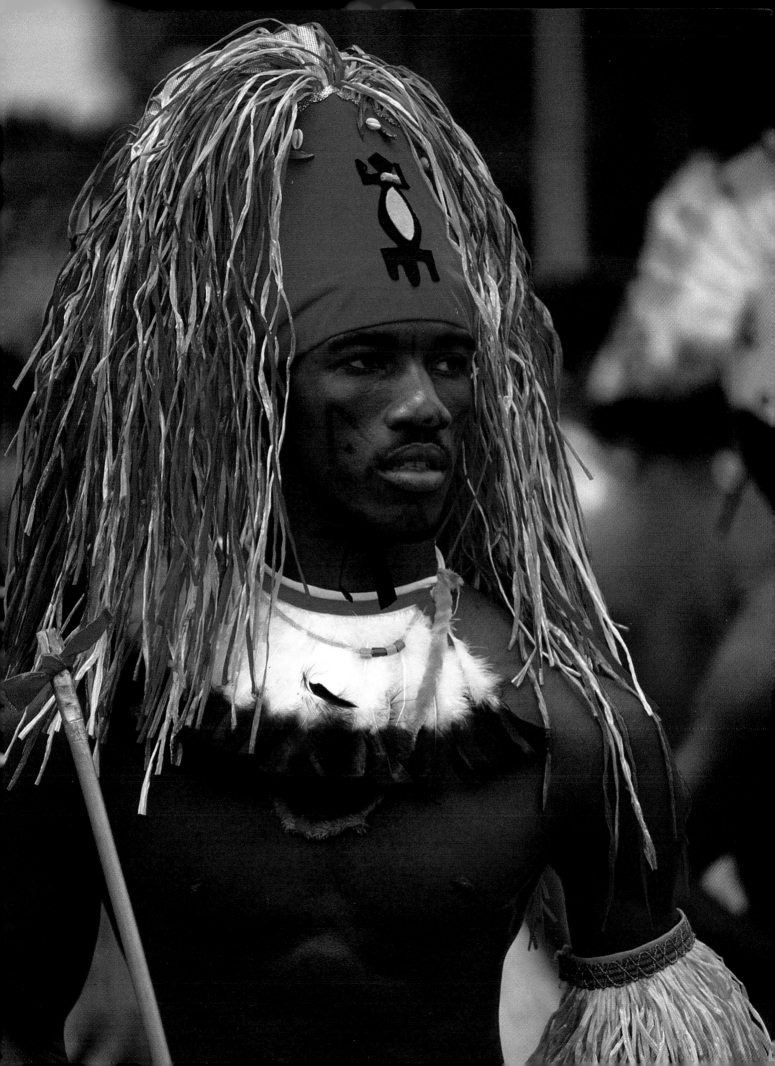

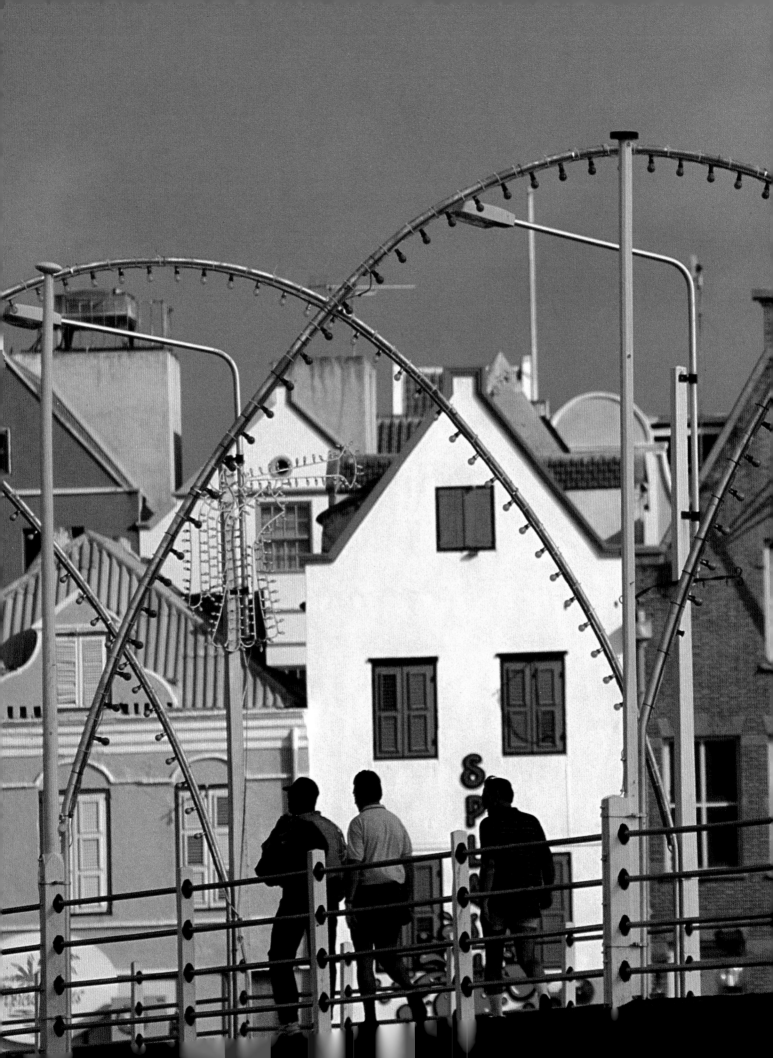

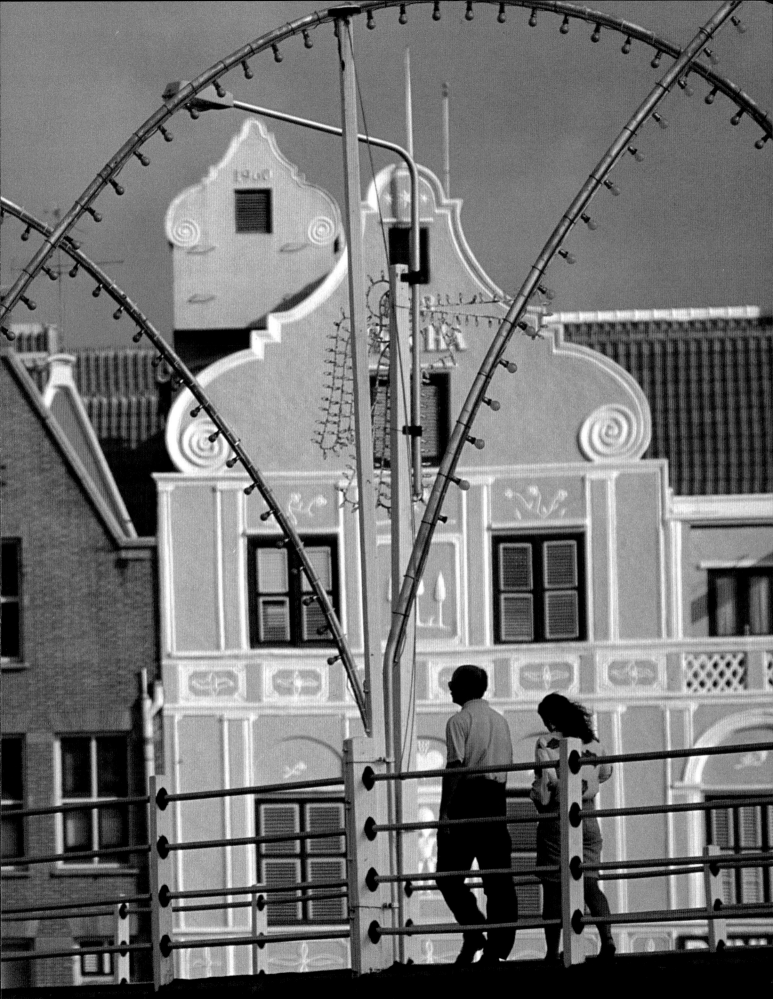

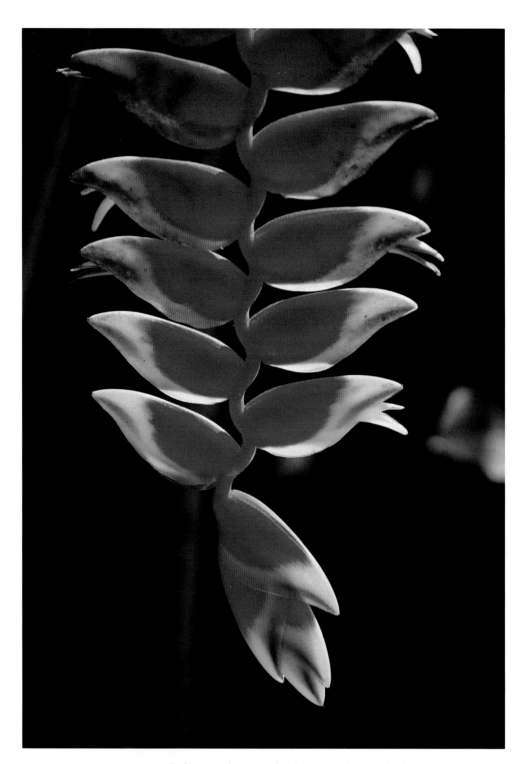

▲ Known as *balisier* in the French islands, *heliconia* hides its simple flower inside dramatic bracts. ▶ Rocky coasts make portions of some Caribben coastlines more dramatic than hospitable. ▶ ▶ The constant breezes off Malmok Beach in Aruba have made the island a mecca for sailboarders.

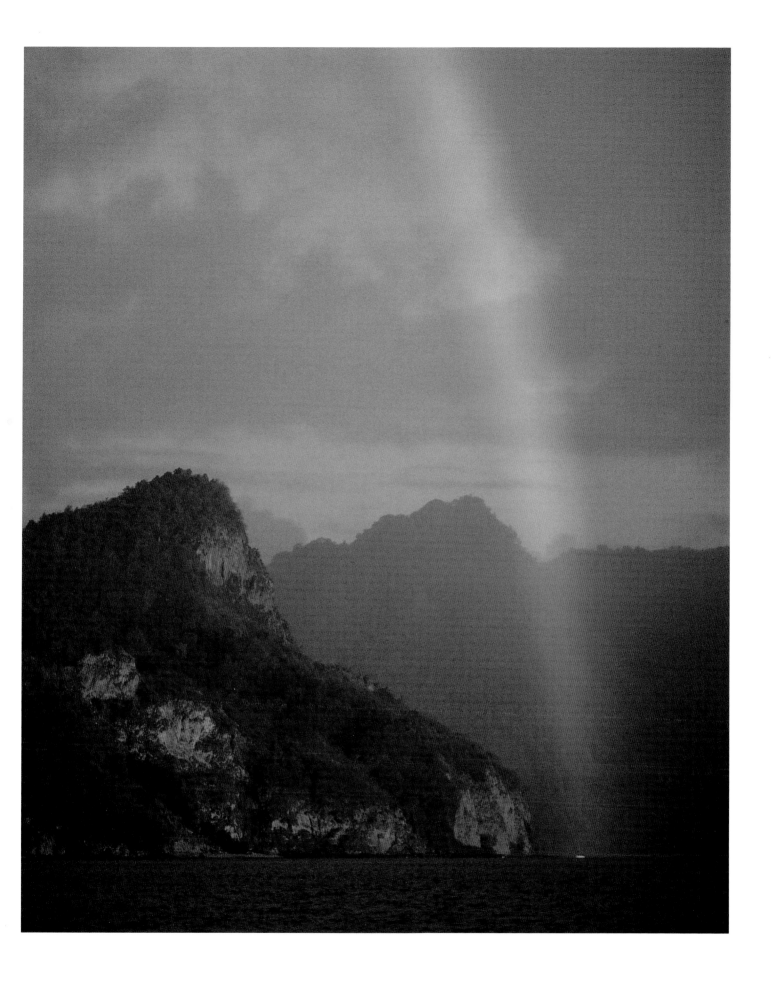

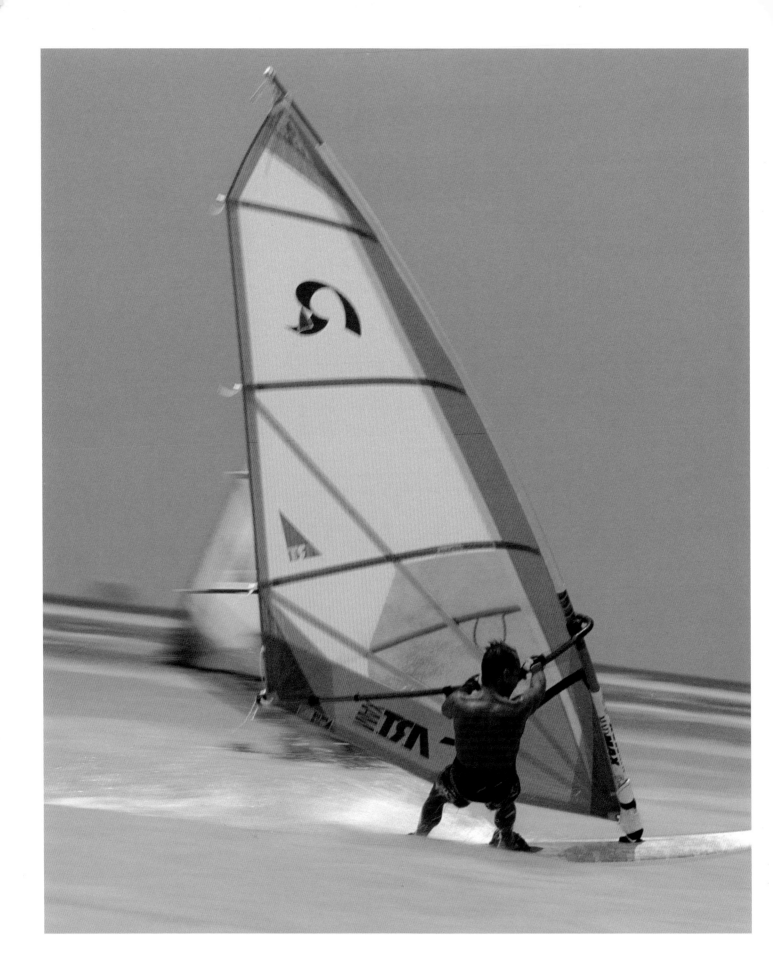